A NORTHERN SPRING

A Northern Spring

by Matt Mauch

TRIO HOUSE PRESS

Mauch, Matt
1st edition

ISBN: 978-1-949487-16-9
Library of Congress Control Number: 2022949554

Interior design by Hadley Hendrix
Cover design by Joel W. Coggins
Editing by Tayve Neese and Hadley Hendrix

Trio House Press, Inc.
Minneapolis
www.triohousepress.org

for Minneapolis

Table of Contents

March to May 2020:
Evacuation, Lockdown, Uprising

THE ANNOUNCEMENT
Excerpted from *The Washington Post*

In the final days before the United States faced a full-blown epidemic, President Trump made a last-ditch attempt to prevent people infected with the coronavirus from reaching the country.

"To keep new cases from entering our shores," Trump said in an Oval Office address on March 11, "we will be suspending all travel from Europe to the United States for the next 30 days."

Across the Atlantic, Jack Siebert, an American college student spending a semester in Spain, was battling raging headaches, shortness of breath and fevers that touched 104 degrees. Concerned about his condition for travel but alarmed by the president's announcement, his parents scrambled to book a flight home for their son—an impulse shared by thousands of Americans who rushed to get flights out of Europe.

Siebert arrived at O'Hare International Airport in Chicago three days later as the new U.S. restrictions—including mandatory medical screenings—went into effect. He encountered crowds of people packed in tight corridors, stood in lines in which he snaked past other travelers for nearly five hours, and tried to direct any cough or sneeze into his sleeve.

When he finally reached the coronavirus checkpoint near baggage pickup, Siebert reported his prior symptoms and described his exposure in Spain. But the screeners waved him through with a cursory temperature check. He was given instructions to self-isolate that struck him as absurd given the conditions he had just encountered at the airport.

The sequence was repeated at airports across the country that weekend. Harrowing scenes of interminable lines and unmasked faces crammed in confined spaces spread across social media.

The images showed how a policy intended to block the pathogen's entry into the United States instead delivered one final viral infusion. As those exposed travelers fanned out into U.S. cities and suburbs,

they became part of an influx from Europe that went unchecked for weeks and helped to seal the country's coronavirus fate.

"Ultimately, I am a culprit in bringing coronavirus back to the United States," [Siebert] said.

From "One final viral infusion: Trump's move to block travel from Europe triggered chaos and a surge of passengers from the outbreak's center" by Greg Miller, Josh Dawsey, and Aaron C. Davis, with contributions for Julie Tate, 23 May 2020

PRELUDE 1

Wed., 10:35 p.m., 11 MARCH 2020

P—I am not sure if you are receiving my texts, nor I all of yours. It is like we are in different regions of outer space, or are existing in the ever-popular "different dimensions." I was up later than the rest last night, per the norm, like a good old kitchen light. "Gale force," for the record, is too hackneyed to do justice to the pounding that Derry was, perhaps aggrievedly and not indifferently, receiving from the Big Indifferent. Think of all the tales you've heard of an Irish spring and turn that to eleven, only take away the there-is-a-god interludes of sun. The braggadocio we Minnesotans have regarding our changeable weather has been rendered impotent here by the temperamental ravaging of all this near-the-sea-ness. Praise be to this old brick building in which we have rented enough rooms to stretch our legs and etcetera in. It is unmoved and unswaying—a secret member of the wind's sect, perhaps, or, dare I venture, that the lintel of the entrance is marked.
MM

Wed., 11:05 p.m.

P—I just read in the *Guardian* that Dear Leader has announced a travel ban for "everybody in Europe." I've checked to see how the *Post* and *Times* write it, the old fact checker still alive and well within me, like one of the last remaining survivors of an old tragedy, the lessons I have to teach of the sort that only PBS cares to remember. Bless these reporters trying to clarify what he means. They are like an underground ready to rebuild once the armistice comes. Seems it's not all dog whistling. They are saying to a source that the ban goes into effect at midnight tomorrow, all carriages then transformed into pumpkins. Aer Lingus—they've a good app—shows everything is still a go for our return on Sunday. Though it would be too early to announce any changes, the officials there relying on the same breaking news as the rest of us. This idiot tale-telling, for we with our wee wild and precious lives in Derry, signifies, contrary to Faulkner's take, quite a bit. The others are awake in their bedrooms. I hear them, on their phones trying to make sense of the announcement, I'm sure. My feeling is not anxiety, but something halfway between the dull clockwatching one does when proctoring a final exam and the suppression of expectations one engages in upon hearing you're a finalist but that the judge needs more time to make a final decision. I sit here trying to do my best imitation of this lovely brick.
MM

Wed., 3:21 a.m.
P—We'll see what tomorrow brings, I guess. It is that time in the
summer when the morning birds sing, although, as Pavlov proved, I
do not need their song lo these many years in to know it is time at
last to turn in and maybe dream of breathing underwater.
MM

Thurs., 7:49 a.m.
P—When I got to bed last night, A. was texting back and forth
with her boss, who was offering to pull some strings to get us a
flight home ASAP—a feat I believe her quite capable of, a kind of
corporate-world glass slipper to best the midnight tolling of Trump.
My own boss has informed me via email that the funds previously
appropriated for this trip have been subsequently rescinded, per
a dictate from the chancellor. If you're still writing, we're sending
our texts to some dead letter office on the moon, it seems. This is
the second year in a row the funds I've counted upon reimbursing
me have been pulled out from under me, leaving my feet and bank
account cold and bereft. It might yet push me to become something
like the rogue HVAC repairman DeNiro plays in *Brazil*. Alas, I'm
doing the research regardless, and the college will get the benefit of
it for free, for I have not the resistive powers of Bartleby, not at my
age. I am no Bobby Sands. I will do a much smaller thing: I will find
a new spot today for coffee (for A. and I) and pastries (for all but I),
like a mouse or other creature of the dirt whose settled path has been
erased by deluge.
MM

Thurs., 8:31 a.m.
P—More and more the Troubles, as I speculated, seems to be perfect
as lens through which to see better our own violences, fractures,
and feuds—the spades of domestic terrorism we seldom call out as
such—and more and more I have the sense that the expansiveness
of our geography, our sea to shining seaness, is what keeps us from
descending into open and perpetual conflict with neighbor and kin,
and as well from facing what we need to face if any of our mottos
and creeds are to be anything other than curriculum. There is too
much water in the pot and not enough propane in the tank to get us
to the boil that turns a set of ingredients into memorable soup. It is
as though after the Civil War we have been placed into suspended
animation for the long trip to strange new worlds where none have

gone before, lacking the boldness of doing it with our eyes open wide. This trip has been as fruitful as a tree from which you can't give away all the edibles before they rot. I have listened and learned much. Those to whom I've listened are always sad to tell me what they have to say. It is why the commingling of coffee and whisky for breakfast is so easy to embrace as its own sustenance, why using real cream indeed matters.
MM

Thurs., 1:11 p.m.
P—The rain and sun alternated this morning with a regularity that made me think the weather, if one could see it from above (us like incidentals or extras in it) would look like the striped pelt of a zebra, we the parasites hitching a ride. We donned our rain shells. Removed them. Donned them. Removed them. It was as if we were readying ourselves for a first date, or an interview. The "not paramilitarily inclined living their lives hoping they won't be caught in the crossfire or crossbombing" is us, no, hoping not to be in the next Las Vegas or Orlando or school that the next shooter du jour targets? It is very much, I'd argue, like Michelle, Erin, Orla, James, and Claire trying to come of age in 1990s Derry, which, furthermore and to conclude, is why we picked a tour with a *Derry Girls* focus. G., a historian and our guide, took us through the Bogside and City Centre and along the famous walls. Though not strictly analogous (these Derry walls intending to keep things out, and the interstates that ring our cities intended, at least in part, to keep things like poverty and black neighborhoods in—lest the suburban set driving through experience a Griswold's-in-St. Louis scene), standing on the Derry walls nonetheless has me thinking of I-494 and Rondo. G. isn't worried a lick about the virus. If he gets it, he gets it, he says. G.'s father was one of the fourteen killed on Bloody Sunday. As we were taking pictures of the memorial mural, where the faces of the fourteen make a circle of ten with four more inside that perimeter—a kind of clockface with no hands—G., as I remember it, said his dad was the face at four o'clock. A. thinks he said his dad was the face at two o'clock. G.'s bravado as regards the virus is not, I don't think, the swagger of the swashbuckler, not the fatalism of the determinist, not the assuredness of the young man with an idea who does not yet know the subtle fruit of thinking with a fully formed brain. It is, rather, the kind of flower that blooms when one walks shoulder to shoulder on streets palpable with ghosts. It is, fyi, hard to take notes

in the rain, even with my very functional and appreciatively portable, but apocryphally marketed, Space Pen.
MM

Thurs., 1:47 p.m.
P—Nearly all of the pubs have designated booths where placards caution patrons that they must vacate the space if a musician wishes to claim it, purveyors of Irish music slotted just below the nobility and gentry, it seems. These booths have been magnets to our steel. We sit, see the placards—metal or wood, the words of which are often rubbed away by use, as on old tombstones—and are amused at where we find ourselves once again, in borrowed space, on borrowed time. These troubadours, the bartenders say, drop by and serenade regulars and tourists both, all of the day and all of the night. The bartenders add *usually* as a kind of apology. Per G.'s recommendation, we are drying out, like a small pack of hunting dogs, at a place called Peadar O'Donnell's, which G. said is either owned or founded by the brother of someone renown in the IRA, but I don't remember who— again the issue of note taking in rain and having to trust only in the recall of a brain nearly full. We have been told a number of times that Northern Ireland at this time of year is usually teeming with Chinese tourists. Their absence is another casualty of the virus, one we likely would not have known of had we not asked, like an old genocide kept under wraps.
MM

Thurs., 4:12 p.m.
P—We ran into G. again on our way from Peadar's to the Grand Central, and he smiled as if a network of watchers had already informed him we hadn't left Peadar's since we'd left him, that what otherwise would seem like a random meeting on the streets was preordained. G. had his hat off and had changed into going-out clothes, wearing the brogues so many Irish men wear, if my few days experience counts as any sort of record of the fashions of the day, his wife on his arm, like one of the couples in a cityscape of good times. G.'s wife laughed when he told her where we'd been all afternoon. It was the laugh of one taking another's baton, as though we were besties having just watched a rematch between our favorite opposing teams, the dollar that we bet each time transferred once again.
MM

Thurs., 4:31 p.m.

P—We're dry now, shells off, having tangled on the road from pub to pub with wind instead of rain, readjusting on the fly for the gusts that come off the quay, not unlike cars at highway speeds intermittently having to sudden-turn left and right to accommodate farmers having surrounded their homes with groves, where the wind is broke. A.'s boss wants to get us all seats home with her Delta pull—wants to use her miles—but Aer Lingus still shows us on time. For the time being, we have the hope of one heavily indebted and sure that a seat with the high rollers in the back room will come with the luck that turns it all around. I feel like one of those characters whom the novelists say speak to them and change the course of their books. I hope our author is not too set in her ways to turn the ending up.
MM

Thurs., 4:54 p.m.

P—The first night here, fresh from Bushmills, we wandered into the Grand Central, and—the tune our stomachs were singing being rather forlorn—asked in a drinks joint about the food they didn't serve. Pyke 'N' Pommes was only half a block away and not yet closed, so while D. and I waited for takeaway tacos to eat back at our booth, A. stayed with our pints, staking our claim. The bartender set A. up with a couple of counter-display-sized bags of crisps—on the house, as if we were regulars already, by dint of showing up in need.
MM

Thurs., 5:40 p.m.

P—You know how when you travel cross country on the interstates you'll pass or be passed by the same sets of travelers days in a row, as if the country and its roads were a kind of board game, all of us with our various playing pieces taking turns in the lead? It's been that way with the bartender from the Grand Central. We have crossed paths three other times, most recently at the Tesco where D. and I went for stock. I could easily be stranded here, quarantined in Derry, and I mean *easily* in five of its seven forms, all of which I've looked up. While our financial hand has no run of the same suit, not face cards or otherwise, and nothing close to four of a kind, I'd say we have a high pair bordering on two pair if we get the right draw—enough to overcome our lack of savings if we pool the spending limits on our credit cards as a kind of kitty. It would get us by for a not-insignificant while. If not for the cats at home, I would be suggesting

more than a little bit that we hunker down here and see if, like the creatures adjusting to climate change by marching north, it is our natural habitat which has moved, and we are merely completing a match that was always meant to be. Perhaps an extended sojourn, as with the faces of those long married that grow to resemble each other, would turn us into expats, Derry our home.
MM

Fri., 2:44 a.m.
P—I've been using A.'s toothbrush since we got here, but following the Tesco run now have my own. Having unsheathed and tested it dry, it is firm but not too. I do not think that the Crest, which I didn't forget, will mix with the Bushmills, and so will have to give my new implement its inaugural launch tomorrow. We'll see what a new day brings.
MM

Fri., 7:22 a.m.
P—I was just stopped by a stranger on the street on the way to get coffee and pastries for the crew—it felt like my last day at a beloved job—the stranger asking directions to Tesco. I gave the directions like a local, even using *wee* as the all-purpose modifier it is here. Reports now say, because we have not left the island, that we are not included in the first ban, but will be included in one soon to be announced, scheduled to take effect Monday at midnight. Aer Lingus recommends arriving three hours ahead of what is a still-on-time, early afternoon flight. There is a something here I have not got enough of. I feel a need to return, like a past life bubbling up into the present life of one who claims they are not singular but made of many things.
MM

Fri., 7:37 a.m.
P—Seven degrees between the four of us, plus a tour in the US Navy, a tour in AmeriCorps, and we had to google what *Schengen* means. It is as if our author got tired of letting us steer and made a stand, and let us know that she was doing so, as she ought to, her name in full being the one on the cover of the book to be, her all caps surname reverent for the particular and general dead of a line for which she is an endpoint, anchor of its spine.
MM

1

Some thought that moderate living and the avoidance of all superfluity would preserve them from the epidemic. They formed small communities, living entirely separate from everybody else. They shut themselves up in houses where there were no sick, eating the finest food and drinking the best wine very temperately, avoiding all excess, allowing no news or discussion of death and sickness, and passing the time in music and suchlike pleasures. Others thought just the opposite. They thought the sure cure for the plague was to drink and be merry, to go about singing and amusing themselves, satisfying every appetite they could, laughing and jesting at what happened. They put their words into practice, spent day and night going from tavern to tavern, drinking immoderately, or went into other people's houses, doing only those things which pleased them.

— Giovanni Boccaccio, on The Black Death, 1348

When we gather again, lap to lap to lap around a fire

Like space dust, we will coalesce.

We will tell our secrets and say our hellos
with freshly foreign tongues—

new accents, new idioms,

no subtitles
to help us understand.

As with a pop song
we can't decipher the words to
but love,

we'll shimmy,

shake,

hit all the vowels,
most of the chorus,

an open-air bowl,
worship

with no prophet,
no book,

no lid. We will evolve
into a cemetery,

sure,

but first we'll be that marsh
in that spring

beckoning to all the birds:
Return.

Old woman on porch plus me walking to get takeaway breakfast make social-distancing exhibits A and B

> *Although one could well make one's own eggs, etcetera,*
> *many of us did our part by stepping up/out to purchase our meals*
> *at greater expense than the meals we could fashion at home,*
> *buoying the places we hoped would make it to the other side.*

Not interacting. Landmass-like.

Like landmasses passing on supercontinent's
possibilities because of supercontinent's

responsibilities. There's no woman

when I walk back happy
because the food

I can smell
smells good, and I bought enough
for a second meal later today. A ceramic bluejay

is what the woman
turned into. We can also turn into

metal chairs and horizontal shafts of light
the low spring sun

uses to tempt us, and tempted
we can tilt things

off the axis.

On the way back with coffee

that you sip
carefully so that your tongue

isn't burned
as you try to suss

how hot hot the coffee is,

two eclairs in your bag,
walking

in a no man's land
where the rival seasons
lob their cylinders
of gas—

cloud, cold sun, rain,
warm sun,

sideways rain, wind,
snowsquall

trying to stick—

you will find that I have turned
into an empty bird feeder.

That I have put the onus
on you.

The parlor game that the self-quarantined and childless play
as they toss a dry cough back and forth like a ball in a game of catch

When you met me, I was the story
 of a door that needed WD-40

 for any to hear my quiet song (a Leonardo)
 over the sound of the friction of rust (a landscape
 painted over it),

but of WD-40

 you had none. Plus you read the last
 page first, where I come across

 as a door excitedly lapping
 visitors always coming to, going from

 a distance—it looked like I could be
 part of the story of the buying
 and selling of drugs

to those who don't see
 their own story
 being told

 ever.

 •

Being the story of a door
 is also being the story of hinges,
 both of which I was
 until I became

the story of he who comes across
a grenade. As a child who unchildlike lifts a car

 its mother is trapped and dying beneath,

undoorlike I smothered the grenade, absorbed
the shrapnel, and in saving my friends

turned into a story about fruit
you would wallow in if it weren't

for the one big seed
taking up nearly all of its guts.

.

Because of all the hubbub in heroism's

wake, you couldn't hear how desperate
my creaking had become.

A creaking door is never a story
of the buying and selling of drugs door,
the private investigator said,

is the payoff of rethinking things
and rethinking things again

and again.

.

Knowing the story
of me as almost-awesome fruit
(and taking a bite)

is like ripping off, with your teeth,

a door that isn't a door
but is a cloud

disguised, as I was,
as a story that's holding back

the oceanic in search
of a basin.

•

In a recurring dream, I

 think I am settling down
 when with WD-40

you've finagled
you turn my creaking

 into easy listening, and together
 we are promoted to the story of a nest, our

 résumés showing the good work
we've done as door and fixer.

•

In a recurring dream without you in it, I'm the story
of the airiest knuckle in a twenty-

 fingered hand. The normal palm
 of the other hand cracks me

ritually.

•

Before you knew I was a story
still being told,

 and only starting out as the story
 of a door, is a time we think of
as our own personal BCE.

•

The story of

 a door pulled like this, by a body
 my size, leaning so and accelerating,

as if into an antagonistic wind,

never having been the story of a sailing lesson,
is the story of a door that will close.

It will feel like keeping a crowd
from getting backstage.

•

Sometimes at the door in
a story you are sent off

with a snapshot of the two of you
that the sender would rather keep.

The unfocused background.
The fashions of the day.

•

In a twist on the old story of
the locket, I have slipped into your hands

the story of the cat curling up
on the jacket I decided

it was too warm out for,

so I dropped it to the tile, leaving me to wonder
if ever else I have accidentally and unknowingly

bequeathed such pleasure
to another left behind.

•

An opera singer within earshot,

when she practices scales,
is the story of a hundred-handled door.

•

It's surprising how much a door
freshly painted can hide

about it's past.

•

The story of
the closing of a door for good

is like skydiving
in that the decision to jump

is the decision, whereas the story
of never opening a door is

the story of dying with
WD-40 on your shelf.

•

To make

room for the opera singer
and the song

she is the story of, we have become
the story of something else,
then something else again,

like we are many seasons, the opera singer's song
the story of a hook

threaded through which
we are bait.

**Like the remaining characters in a tragicomic novel
on the page after novel's end**

> The half of us
> who slyly positioned ourselves

> so that we would not be sitting

with our backs to the door

> hope, like the senders of messages into space,
> that our knife-and-eye-work

> > is telling the others

*tonight we put away
our guns.*

"The bog-bodies of the late first millennium BCE are a classical archaeological puzzle: men, women, and children murdered yet respected in death and adorned with items of fine clothing. Bogs could have indeed been seen as liminal places positively connected to another world, which might welcome contaminating items otherwise dangerous to the living."

from *Roman Reflections: Iron Age to Viking Age in Northern Europe* by Klavs Randsborg

A stretch of window glass perpendicular to the sidewalk
　　　　　is saturated

　　　　　like a bog
　　　　　with the reflections

　　　　　of everyone who's ever walked by, everyone

　　　who's ever eaten inside. I touch it (the glass) like
　　　　　　　the mournful walk on sacred ground
　　　　　　　(it was warmer in my mind).

The bird shadows seem to be speaking
　　　　　　　　　　a language the glass can interpret.
　　　　As if they're telling it their secrets,

　　　the shadows mark a point of entry with X
　　　　　　　after X. I put my ear to the glass and
　　　　　　　hear, *I see*

you. I hear, *I just had the best pancakes*
　　　　　　of my life.

　　　　　　　　In the math of the moment, a plus sign
adds the glass I see myself in

　　　　　to the understanding that it is glass
　　　　　　　　　meant to be seen through. The minus sign
　　　notes that my reflection in it looks

nothing like a one-man-band. The equation

zeroes out. One of the thoughts
 I have at zero is that loitering

may be the bow that plays the fiddle of bliss.
It is bliss that
 allows a part of me

 to dive not through
 but into the glass
 at the X,

 where I join the light of day,

the confluence of room and atmospheric temps,

 tiptoeing through the green trains
 that trail the fishes

I didn't know lived in glass. I settle
 cross-legged, a bottom feeder,
 a buddha in a tank. I pat

 my head and rub my stomach. The fish
 school around me, try

to impose their will on my soon
to be precipitate body-stalk.

 They are trying harder than any ever have
 to recruit me

 and are succeeding.

Even with my breath held

 to recapture the old sense of buoyancy,
 I no longer rise.

Ask me what you would ask

 your go-to objects of veneration.

Ask me what you would ask
of the dead.

Our smiles were hidden

Like fire meeting fire
and burning all the oxygen out,

we stepped into the street,
stepped back,

 a courante

almost. Like

dancers at the end of a song,
 resisting

 the protocol that says
 separate.

 Like flavors of ice cream
 turned to cold soup

in a bowl.

Say I returned from cardio
with no other gift.

Gesticulating in the driveway, maintaining more than the requisite six feet between our physical selves

These arachnid-ish shadows
 we're casting,

 the Saturday prior to Easter,

 I wish could be Pompeii-ed.

It makes less silly

a future in which we cuddle
together in trees,

 reincarnated
 as koala bears.

Joy is so often

 the mirage of water a playing field
 ahead of you on a summer road,

 is why (I'm sorry) I'll have no choice

but to continue to drive so recklessly fast.

 I do not want to be like those
 whose joy is a lozenge wrapped in foil

 that they're saving in their pockets
 for later.

When I prairie dog
 look up and around,

 I see so many people's heads
 possum-bowed.

Nudity has become the opposite of what it is.
An academic concern. A parlor game.

 Not an animal thing.

41

Remembering with an artificial yellow daffodil, gotten by a free-will donation, the sacrifices some make for change

Snow, intent on outlasting thaw,
squats in the neighbor's back lawn,

> in shade.

>> Bouquets of mail
>> blooming from mailboxes
>> all along the street

are accomplice,
diaspora,

like the lapel pins
> of those unstrange
> strangers

>> whose eyes meet mine
>> and wax.

During a long and early walk in a foreign town, from where the US president has just banned travel, where only the locals getting ready to open the shops have yet to stir

I mouth *0.00849375* and dates
and other data
 over and over,

 sucking and blowing on the facts
 of the world.

 The facts
 and whatever is in the air

 struggle to converge
 through a scarf

 that, in this weather,
 none will mistake

 for a mask.

 How wonderful
 how everything

is a woodwind instrument. How,

 kissing hard,
 we make an atmosphere,

 play the invisible reed
 of the fire we feel

by ear.

Unable to hug with our arms and torsos and heads

We hug with our eyes and grow obese
with seeing.

> Obese with seeing,
> we yet are able to close in

> > quickly enough to see again.

> *In the art of seeing,*

> > *we have the deceptive speed*
> > *of a hippo on land*

is what I write in the steamed-over mirror
of a hotel bath.

Each moment
> *is a fossil*

> > *of sight*

is what I write
next to it.

> I reuse my towels,
> tip the staff,

> make my own bed,

wipe down the toilet
and tub.

> I stay and pay
> and shower

> and never get to see

my words eaten
with a hand and rag,

whether a response
to my call is inscribed

in the glass when the glass
is delible.

Which, recluse to recluse, I have named Emily Dickinson

A dead branch in the belly of the tree,
hanging straight down

 while the other branches reach,
just some tree skin holding it in place,

 as if ousted,
 as if refugee. Branch

that you have to be standing in the right place
 to see

through the gaps in the leafy green,
to acknowledge with your eyes

 the wish you share with it
 to change the world as it is.

This is not a music video.

The branch is not a lemon.
I am not on sale.

This is an offer of clemency
at a happy ending

 that is also a blind beginning.
 The knowing branch,

 as if dethroning
 this era of fencing-in,

 (for the public
 I am about to return to)

 has given me
 a piece of corduroy

to rub with, to get the many many masks
 I've both been issued

 and have adopted freely

off my face.

 You will never see the me
 you think of as me

 again.

My face is becoming
all light.

May we the lessons from now apply STAT to climate change and do so in memoriam

As at the end of a quiz
or riddle

 or game show,

we are revealed to be neighboring ponds.

 Those who die

are like trees

 at our perimeter
 in a time of extraordinary rain,
 leaning over

as their roots get noodle-y. They are becoming
 giraffes dying face down in us.

 Eventually, drought.

 Eventually we will be chewed
 by landmasses.

The giraffes will grow appendages, heads, teeth,
 maybe fins.

 They will be the heroes
 of the archaeological dig.

We will have been their compost,
their loam.

Following the lead of Danes

Where fiercely oppositional parties across the political
and labor spectrums united behind a plan to prevent mass
unemployment, whereby the government pays for workers'
salaries for employers who do not lay them off, and also
for rents of companies who suffer revenue shortfalls
who similarly have not conducted layoffs.

I'm watering plants in the rain, antiserum
to austerity, practicing the art

 of pretending to belong
 to it all,

 a transcendentalist,
 or over-soul,

 or octopus
 with tentacles

 ad infinitum,

 dropping welcome mats
 on every doorstep,

 like a greeting

translated into every language
and fanned out

 like a bird tail
 is a season of display.

It's why you feel like
you're being followed.

 Why you turn
 to no one there.

Today I am arriving
in the blue areas of the weather map,

a spring snow
 falling wetly enough,

 dryly enough, not accumulating
 too much, holding

whatever your soles to-ing and fro-ing
have to say.

 I will melt
 through what is still called

 solid ground,

 a summary
 of our amalgam,

 a sherry
 that finishes the dish.

 From outer space, we look like
 so much lush green,

 lush brown, lush blue,

our framed pictures of the dead
next to our framed pictures

 of the living.

**The ballad of a brunch prep that brings me
from intimations of paramilitarism
to true hopes for peace, the radicalism
of the pandemic making Easter morning
a microcosm of the Troubles**

I crack an egg on the edge of a bowl,
pretend it's the skull

 of one whom I refuse
 to sit at a table

and negotiate with.

 I crack more eggs and think
 again of sects and skulls. My thinking,

 I think, is limited

by the shape of my cookware,
 by what I'm cooking,

 by the tribe of ovoid,
 oval,

 spheroidal, round,

 by the casings
 that keep

 our brains.

I crack the eggs like a crow

 who has figured out its beak
fits perfectly the heel-hole of Achilles.

 Hungry,
 hunched over,

 I whisk,

as in utero, or as if
　　　　　reading a difficult work in a quiet room,

　　　　　sounding a new word aloud,

like a ship captain blowing my horn
in fog,

not as SOS, but like it.

Before the first case in Wuhan, before the primaries,
when Warren and Sanders were leading the race,
I was full of guarded optimism—too experienced,
to be sure, to fall whole cloth, but hopeful nonetheless
for the coming election year

> *Its untended foliage, its ganglion cells, this record*
> *of a simple and unabashed Thursday from the fall of 2019*
> *has the heft of a memento one is buried with.*

Concrete man concreting.

> Painters scraping, taping, cutting,
> spraying.

> Lost cat being found.

The class clown in an old pose
he thinks is new.

> Class clown like
> the clay work of a student

> studying other students as she mimics
> Rodin.

> *Each mandarine*
> *Rodin peeled*
> *altered plans he had*
> *for a face. Thus*
> *his studio extended*
> *to repose, snacking,*
> *etcetera.*

Old posers in
new poses they don't bother

> to tell any of the rest of us
> about, nor what their titles are,

growing into Rodin-ness, as if

saying yes to the offer of marriage
at the end of life.

There are in Rodins'
Rodins so many depictions
of yearning, or whatever
other word you use
for what we mean by that.

All of our private

ceremonies! Nobody changing
out of tux and gown

that nobody else knows
is tux or gown.

As documentarian one,
I go attentively, like a sketcher

roughing a map for the pamphlet
at the kiosk.

A compliment
about one's stunning blue eyeliner

is among the compliments
I hope to make again

and again
to strangers galore.

The I-never-win-anything jinx
is broken!

A woodpecker shadow,
by the time it reaches me,

is as large and stunning
as the shadow

of a pterodactyl.

I look up.
I am *First Time Bombed*.

As if manufacturing
offspring, I have put

the brown nipples of one
into the pink place of another,

the gaze

of the altruistic onto shoulders
archetypal for cold heroics.

I'm smearing seams and all with the yellowish-
brown patina of an old truth,
presenting it like an encyclopedia entry.

*Above all, Rodin
is saying, "See
like the sun sees
when the sun
wishes to evaporate."*

Even the multitasking-est
of multitaskers

will find respite, as if in burrows
I'm leaving behind.

I am trying to lure
the lurable away

from the landscape painting we woke in, its too-cottony interpretation

of clouding up, of peasant bed
as pedestal to last glimpse of sun,

ostentatious presentation of sleep,
of sleeper, as if the audience

coveted only rest.

Not a regular at any
bistro, cafe, or bar, but
like a migratory creature
counted upon to return
now and again, none
of Rodin's servers or chefs
thought of him as an artist.
Artist to artist (the servers
and chefs were not only
servers and chefs),
much is missed.

I must have
loved someone or something

scalding! The whole of me must
have been dipped in and pulled out

in time!

Carrier of many kinds of coin
in many pockets, encounters

with machines that accept them
I take as signs.

If your fetish is blister popping: squeeze me.
Wipe me on your pants!

The fruit fly
I thought had died in my wine

was pinky-lifted onto raspberries
and started moving again.

I will leave the last banana
until it grows old enough to harbor

a generation who may become reverent
 of the fruit fly I saved.

*Those who see the Balzac
in Rodin's Balzacs
and the Hugo in Rodin's Hugos
are seeing as one sees others
walking through a crowd while
preoccupied with oneself.
In a crowd Rodin
was paralyzed. As in
reincarnation, the faces
of Balzac and Hugo
were really many faces
in a stack.*

I myself am ripened to the point
 that my contours belie me to the fingers
 that want to pick me up. The fingers

 may yet eat me, but to do so
I will have to be spooned.

REFRAIN: What
lucky tongue to be put on plus

 and minus nodes both at once!

*This week I had
an electronic conversation
about Uber that was not
about Uber at all.*

It was as if I were texting
Rodin. As if time
and space differences aside,
we had found a way.

The fear of the city in the profiles
of the people on the bus coming in

from out of town, who don't think
I can see them through the tinted glass,

is fear I am pinkying out. How

I turned red for the tomatoes
that refused to this year

is old news that nobody saw!

If you can hold in your head
images of the many many
hands on Rodin's sculptures
and furthermore
can animate them in sequence
as a motion picture does
with still shots, or as a flip-book
does with tiny illustrations
in the corner of a page, the
resulting pantomime, stared at,
becomes a face.

The puddle duck waiting
for the water level to drop

so it can eat its fill simply
by tipping, by coming up for air,

by tipping again, is waiting
for the water level to drop.

I see to mud but

 sculpt water as a plane. See
 to the field where the duck

 is flocked and feeding but
 sculpt its tail and legs protruding

 from the water plain conceptually. It looks
 like an obelisk still growing.

Your carving of me
looks like a toad.

 Were we students of pyromania
 before or after we were students

of wood?

*If all the doors in one's life
that were not seen to be
doors initially were
arranged as if
they were the entrances
to a neighborhood
of enchanted palaces, one
could draw a direct line
from Blake to Rodin
to oneself.*

It's like we slipped though
fingers and fell

into creases between planks of floor
and didn't know it

 until we were resurrected
 in a rag used to wipe up spills.

We are *Prelude to a frieze*
of all the work getting done
before the freeze.

We are *The Unrushed*
Unknowingly Rushing To.

It's like we're pallbearers
pall-bearing.

Our eyes

let in, let in,

weep out, lose one's gravitational hold on,
snare another,

repeat.

Because it is hard
to say that which
hasn't yet been said,
it's little wonder
things often get mistaken
for angels.

Rodin is our new name.

All of the syllables are silent.

We are like styrofoam done up so well
everybody thinks we're concrete.

When in the nursing home, via Skype, Zoom, and FaceTime, the residents speak like Issa

You will think that spring
has landed on your head.

 It is impossible to take a selfie
 of what you're feeling.

 You will be thinking
 that you need a painter to paint
 what you feel.

They will say to you, *Spring
is like new hair.*

 Wear it fancy while you can!

 You try to catch what they're saying
 like the cotton

that the child

 is trying to catch
 in the globe

two hands make.

What they say
when they speak like Issa

falls like a snow

 that didn't receive
 the itinerary
 of spring.

They say, *The cotton is tethered to the wood.
Whomever catches a seed
 catches a tree.* They say,

You are the gardens in the yard
of the home the people purchased
in winter.

You are under snow
like a bear.

You are what they do not know
they are waiting for.

If you must arrive, they will tell you,
arrive as too much.

The goddamned itinerary—the last thing they say—
pretend you didn't receive it!

PRELUDE 2

Fri., 9:33 a.m., 13 MARCH 2020

P—I have tried to take my phone off of airplane mode when in hotspots, but with little luck connecting. I feel like a ham radio operator, or, hell, if I'm analogizing myself into a box, I'd rather be a stranded Amelia. If you've received my messages and have replied . . . well. Sorry, too, for any auto-incorrections. I know better than my phone 97 percent of the time.

MM

Fri., 9:59 a.m.

P—What a brilliant sun today. My brief experience with this Six Counties spring, though, has me reading it like the start of a scene I know will end with corpses all about the stage. D., L., A., and I have triangulated our theys, and so it is with confidence I can report that they are saying we will not get rain till later in the afternoon, and then only for a short spell. Although a rationing-out of rain and sun as predictable as what they're suggesting would be a first, I'm allowing myself to fool myself into expecting a lighter version of the predictable old Florida rains we used to get, when I lived there, before climate change. I'm not unlike a voter at the polls thinking that this which I do here today is enough to make the world a better place. Part of me thinks that, had we an overlay of the weather to set upon our itinerary, we would have moved several of the pieces around. Another part—that part that makes metaphor and distinguishes sentence from line—thinks that getting firsthand knowledge of the Troubles à la Derry from G. in weather that he is as adapted to as a duck is a gift such that we have never received, that we be forgiven for not first seeing it as such. Ah, hindsight. It is almost as good as a pen or pencil to cross out today that which a confident but melodramatic you put down yesterday.

MM

Fri., 2:14 p.m.

P—Back in Belfast now. The three days ago it's been seem "like years," and I am scare-quoting that because the cliché literally has renewed meaning with this stalled sense of time that seems to have been pulled over us like a pall. Dr. Frankenstein, no doubt, has been hard at work, and at least one cliché is his beneficiary, a monster with its arms outstretched.

MM

Fri., 2:22 p.m.
P—We have a spot in the city centre. Our first place, before the loop up to Derry and back—a kind of Sunday comics speech balloon if you see it in marker on the map—was in west Belfast, not far from the Falls and Shankhill Roads and the peace wall everybody signs (or, if you're a local still steeping in the brew, tags). Dm., our Troubles à la Belfast guide, explained how the the wall "literally keeps the peace," in that it stops the rocks and golf balls that the ne'er-do-wells throw over it from escalating to worse: Molotov cocktails and the like. "Peace wall" had seemed to me from the outside as the strangest and silliest euphemism of all, topping all the great ones Zinsser lists in that still-great chapter on clutter. No more. And good god, I'm finding myself saying that a lot, not as a needle stuck in a groove but as a track on a CD intentionally using the sonic effect to double down on the words, or stand in for them if you can't make out what I'm singing for the accent or muddle.
MM

Fri., 2:23 p.m.
P—Speaking of Zinsser: Since he's dead now, I photocopy and disseminate not only the chapter on clutter but all of *On Writing Well*, which I found in whole in pdf with excellent resolution on the first page of results. Copyright law, in such an instance as my students needing to know and not being able to afford what the publishers charge, is, I think, unjust—my own little papal decree, which, for the record, I'm making here and now in the infallible tradition. Report me or don't. Now you know.
MM

Fri. 2:39 p.m.
P—Forgot to tell you about the cages they've erected over the houses closest to the peace wall, which we got both in front of and behind, Dm. leading us around like the locals who used to lead Bourdain. The cages are a tight wire mesh that a golf ball or similarly sized stone can't wheedle or wiggle through. We should make such cages to thwart the indifferences of hail—'tis almost the season.
MM

Fri., 2:44 p.m.
P—To go back to Zinsser for a sec, do you think there's truly a perspective from which an LGM-118, which is as falsely innocuous

as "Peacekeeper" is propagandistic, really keeps the peace—a perspective we can let roam among the paradoxes that pose the ethical scenarios that wash away the false sureties indoctrination and socialization have planted in our minds? I find I must now be open to the possibility, as the "no more" dub repeats and repeats. It's easy, of course, in a political speech to conflate deterrence with peace. But is there something to that, such that it's naive to say as we tend to, "They really aren't the same thing at all"? How does one keep the former from encroaching upon the latter yet still acknowledge the breathing space of détente? Especially how does one do that having now been here? Anyway, enough with philosophy. We're going back into the streets.
MM

Fri., 3:03 p.m.
P—It is like a boardgame of sorts, a damn analogy I know I've been playing boomerang with, like it's the street-flattened remains of a squirrel and I'm eight, what places have closed voluntarily and what places have not. The signs urging us to wash our hands, not touch our faces, that started to show up on elevators and entrance doors in Derry, are everywhere here in the places still open. Curiously, we see them hanging but have not seen one in the process of being hung. I ventured to groans that they contracted the North Pole elves to post them during the night, it being a slow season for toy-making. That place we rented when we stayed in west Belfast was across the street from the Sunflower Pub, which is one of the voluntarily closed. We got on especially well with the pizza maker, who worked from a wood-fired oven in the beer garden, his pizza station roofed. The pizza maker had been to Derry and Portsmouth and gave us pub recommendations that are now on the "been to" list. We have been led by such recs as a circus lion is trained to do tricks in response to treats. By the last night of our stay, the pizzas were catch as catch can, the pizza maker (damned if I can remember his name) out of this ingredient or that, unable to make any of the specialties on the board. It was as if we had a celebrity chef whipping up something otherworldly out of the sundry condiments found in fridge and pantry, much as Lynne Rossetto Casper used to do for callers on the old *Splendid Table*. We took four whatevers and told our pizza man we'd see him Friday. We had truly intended to keep our word.
MM

Fri., 3:17 p.m.

P—This photo shows the bomb cage at the entrance of the Sunflower—a precursor to the cages on the Catholic homes next to the peace walls, a bit like a fledgling company with a good idea bought out by the bigs. They say it's the last remaining bomb cage in Northern Ireland and that there's been some pressure to dismantle it—to put this aspect of the past in the past, which, I don't think they'd like to hear me say, is rather American of them. This is not unlike the evolution of the murals, where the more violent elements—flowers that indicate kills, for one—have been over time removed as the 1998 peace grows from seed if not to flower then to something in the garden that looks as though it deserves our continued attention, because who knows. As regards the bomb cage, it will come as no surprise that I'm in the "keep it so you don't forget" camp, much as I would try to keep alive the last redwood—or anything redwoodesque—which may become a thing we have to decide to do, what with the warming. The morning before we started the Derry loop, I left our flat, per my new routine—two days of the same thing give me license to call it that—to get coffee. One of the Sunflower bartenders, who the night prior had served me perfect hot whiskeys, was loading in for the day. We volleyed head nods and the Irish version of a "hey." I'd become a regular at a Caffè Nero, a chain place, where I gave my quids to the same friendly barista every day, although here they don't call them that, which is more weight on the scales for here. Not five minutes later the barista not called a barista told me she heard there'd been a case of the virus discovered at Queen's, where she was a student, and that they may be closing things down for a day or so to sanitize. We drove past both the Sunflower and the Nero again today on the way to our place in the city centre and saw the now-familiar "Due to COVID-19" boldface at the top of the signs, after which you don't need to read on. It's like hearing the EAS alert when you're trying to listen to a radio show. I took the bomb cage photo days ago, and didn't think to share it then. It's more poignant now, like a thing one neglected to love, or, in this case, pass through and be hopeful it's a relic.
MM

Fri., 3:21 p.m.

P—The omnipresence of the COVID-related signs, whether imploring diligent hygiene or announcing the temporary cessation of business, bring me back to NYC post-9/11, to the makeshift fliers

holding the faces of all the missing people, all the numbers to call if you'd seen them. I was there on business to schedule and sign off on a series of school-library books for middle-grade readers, nonfiction to complement the curriculum, working with over-placed editors at one of the major houses we had a packaging contract with. We walked the streets somberly at night, one of the editors much better at lower East Side hosting than bookmaking, a population turned to ash on the walls of buildings all across Manhattan looking at us, over us. I remember thinking then, *When these streets are empty, if ever they are, all the dead will stare at each other, all these happy looks on their faces, as if the afterlife were grand—a big party along all the thoroughfares.* Such sentiments in the moment are as close as I get to religion.
MM

Fri., 3:59 p.m.
P—During Belfast prior, we spent three-ish hours with Dm., a fat hour beyond what we'd paid for. We stayed in the van in the Protestant neighborhoods, and not because it was raining, which it was. The lecture, as it was that more than a tour, ended at the Bobby Sands mural along the brick wall of Sinn Féin headquarters—the photos here. Dm.'s Catholicism, he made clear—not frequently but importantly, with eye contact for each of us—is about culture and identity. He's no time for deities, disciples, priests. Although I know the risks of over-extrapolating from anecdote, this seems to be the case with everyone here. In a case from the other side, to balance the scales, our Protestant bartender at Finn MacCool's in Bushmills likewise had no time for concerns of the cloth but was all about sports. He even called it soccer when he heard our accents, like those multilingual broadcasters who break out of their perfect English when they come to the cliff of a foreign word, which they free climb. When we told him we were from Minneapolis, he asked, like a kid, if we were at "the coldest game ever"? He was thinking Vikings v. Seahawks, the playoff loss, a cheering stadium rendered dead silent by a hooked chip shot. Big tragedy then. I told him that I was indeed there and hated to have to correct him, that officially it's only the third coldest game ever. In retrospect, it's a misunderstanding I should have watered and fenced instead of pulling. I had D. convert Fahrenheit to Celsius on his phone, and when the bartender and the three others in the pub heard the temperature in their native tongue, one of them said, "It's never been that cold here ever," after which came a string of expletive-laden decrees of abomination. While D. and I went down

the road to get takeaway from a chip shop before they closed, the
bartender took A. and L. out back on his smoke break to see the full
moon—a supermoon called a worm moon, he told them. Had we
another day in Bushmills, we could have counted ourselves taken in
as regulars once again. So perhaps for the better, the Troubles killed
religion all but in name. A thin silver lining. Which of course makes it
easy to grab and pull out, ruining everything.
MM

Fri., 4:14 p.m.
P—Save for a professor bellied up next to us at The Crown, none of
my teachers here are from the universities. I have nonetheless been a
front-of-the-class student. Not a brownnoser but one of those ready
to fail better to learn more, if I can be so high-minded. Everyone
we've spent the least amount of time with, when I tell them why
I'm here, recommends books to read, shows to watch, sites to visit,
etcetera. They have the inside knowledge I had hoped to find and
are pointing me to what you can see they believe are truer truths.
Perhaps these are the ruins of the underground. Perhaps peace takes
the arteries along which the vital intel of revolution travels from cell
to cell and turns them into advice for the taking, treasure maps or
bread crumbs to follow to the gold. In any case, I hope how those of
the North of Ireland have been with me is how I am with others. The
prof at The Crown had a thousand jokes, and we bought each other
rounds, he getting the worse end of the deal, having to buy four to
our one, more than once. Everyone was buying him rounds as he held
court, working the rail. Perhaps I should teach here. If not perfectly, I
speak the language well enough.
MM

Fri., 4:40 p.m.
P—I keep thinking of Lucille's quote. I have got it both memorized
and hung up on my office door: "it's so nice that you find your tribe,
or actually, what happens is, your tribe finds you. and you are so
happy." The purity I tasted when I first drank it in has gotten a bit
musty toward the bottom of the glass, as if some bad ice had melted
in it. There is the tribe of poets on one hand, the tribes of Protestants
and Catholics on the now three hands I have not got. There is the
rural tribe, the urban tribe, the tribe of happy drunks, the tribe of the
teetotalers. For every tribe with doves, another one or two with guns,
and even the tribe of poets, which I once put so much bloody stake

in, has plenty of undesirables and jackasses in it, social media has shown us that. I can only imagine what new tribes are forming now as the virus spreads. Not even old Durga has got enough hands.
MM

Fri., 5:00 p.m.
P—Four days ago, we were packed in with hundreds of others on our first night in country, like sardines, if nowadays they sell them not by the dozen but packaged in bulk in a tin the size of a concert hall. You liked the videos I posted, and I thought it truly serendipitous—a new illustration to place in the dictionary next to the definition—to be here the night of such an old-person's show, recreating that tour bill from 40 years ago that neither of us was old enough to attend: The Vapors—and I get a chill saying it—opening for Foxton's third of what's left of The Jam. It was also, it seems more and more, the opposite of serendipitous: a kind of insect trap baited with the syrup of musical nostalgia, hundreds of us shoulder to shoulder, hip to hip, weaving our individual ways through the singular mass we made, like bugs under bark, getting our beers, going to the toilet and back, stepping out for a smoke. The Limelight would remind you of First Ave without the second floor. If something was in the air or to be gotten from rubbing against the upright body of another, we middle-agers, reminiscing and no doubt accounting for a goodly number of pre-existing conditions, were making sure it had its pathways. Not serendipitous for us, but for the virus, yes. Perspective.
MM

Fri., 11:30 p.m.
P—The Ox website says the wine bar is closed, the dining room open still. We arrived early and got seated immediately, at what seemed to me the best table in the house, front center of the mezzanine, overlooking diners on the ground floor, beyond them plate glass (beyond that a street) in which you could see a rectangular reflection of the kitchen, the cooks and chef at work, a picture in picture, like a take on The Last Supper if irony isn't completely dead. We felt like we had been ordained VIPs, one of us perhaps a doppelgänger of a celebrity we know not of. We made fast friends with our waiter, a convivial young Frenchman planning to sojourn soon to New Orleans, to stay the summer with his girlfriend there. I had a fleeting thought of Linklater and the *Before* films. We told him all we knew about New Orleans, and that his good French wouldn't get him

far, that it would be as useless as even our American English is in those pockets of the south where the vowels are long shallow pools, the consonants aggrievedly rising from pockets of mud to break the surface when it gets too still. At the end of seven courses, with two or three extras thrown in—a bonus likely a result of the fact that there were uncharacteristically empty tables, plus the general sense that everybody was biding time till the all-closed orders came down—we felt as welcome to stay as long as we wanted, much as we would in a café in Paris. It is nice to eat well and (I imagine) work in places where one's good wages aren't tied to tips. It is nice to have camaraderie spontaneously combust, to have it have nothing to do with hierarchy, transaction, or economy.
MM

Fri., 11:48 p.m.
P—When we made reservations months ago, not knowing conditions would have allowed us to walk up and get seated like relatives of the chef, we were told, via email, that the menu changed daily, and we had a two-hour limit to dine. Tonight we stayed for nearly four, blowing up the affordable part of our *special but affordable* (from the website) night out, as if we'd inside knowledge that the world was ending soon. On a side table, illuminating a row of cookbooks, was a desk lamp featuring a proud, hands-on-hips Bib—a pose altogether different from the running Bib embossed on the sidewalls of the passenger and truck tires I used to swap out from wheel to wheel as a working teen. I would bet most in the US who know that there is Michelin the tire and Michelin the critic do not know they are one and the same. With all the Dunning-Krugers and anti-vaxxers, one could not show them that the compass face says north and convince them they were not going south. Bib is trimmer today and waving in a studio headshot rather than running full-bodied on the side of semi tires. Has social media succeeded in making shape-shifting Bibs of us all? Less rhetorically, was the duck my favorite? More likely it was the pairings of wine, which made me think of N. at Corner Table and his paring sense, which I think is unrivaled. It is too bad CT closed. Too bad, too, that I cannot get an iPhone shot to turn out of the cooks and chefs suspended in the glass. It could win a prize.
MM

Fri., 11:59 p.m.
P—We nearly missed what is one of the first bars I'll hit when I

return here. I'll be like one of those dogs lost on family vacation who months and miles later finds its way home, skinnier, to be sure, for the wear, and ready for a drink. We nearly didn't go there because of a photo D. found online that shows what I'd fairly caption, "Bittles, daytime, interior, opening day." The bright red-and-white striped theme puts one in the mindset of an ice-cream parlor. Perhaps it is like a "Beware of Dog" sign posted on the front doors of those with no dog, used to keep the more weakly constituted among us from knocking. The red and white IRL of Bittles is appropriately dingy, is what I would call tastefully gaudy, worn in like a popular run of wooden floor, and everywhere are murals of various heroes of Irish sport, politics, and literature, a kind of pantheon. This is the city centre, where Dm. says the young people from both sides are talking, getting along, starting something new. There are some things that only time can salve. The common cold is a regular lesson in that, one we too easily discount. We grabbed the last four top in Bittles, the clientele and staff of which were a mix of ages, an entire spectrum from beautiful youth to the wisdom of age. The only thing that might have added to the effect was to have been here in the era of smoke-filled bars, something I was strangely nostalgic for tonight, never having been a smoker and never having liked to have to wash the hair I used to have before infecting the pillowcase. Of Bittles, I have picked up its scent. I can get you there.
MM

Sat., 12:22 a.m.
P—If Michelin's food presence in the states were anything like its tire presence on SUVs, almost every one of our birthday and anniversary dinners out would be had at a place bestowed with the famous (and, as we've talked about, lately infamous) stars. And, of course, almost every place that we'd take with us in the what-do-you-take-with-you-to-a-desert-island game would still have none. Had we not had reservations at The Ox, the consensus is that we would have settled much further into our chairs at Bittles, to the point where their shapes conformed to ours rather than vice versa. I have also stored the scent of a place called Made in Belfast. When we bivouacked there our first time through, I returned to my days as a journalist, when I worked for one of those bratty and brash weeklies, the staff comprised of gadflies—influencers before we called ourselves that—impatients, pragmatics, idealists, each taking turns at each. We would daily scour the city in search of the best Bloody Mary, etcetera,

a year's worth of that kind of research and notes leading to the week of deliberations during which we would hash out our annual "Best of the City" list, emerging with what felt like a consecration. Were I still such an intrepid, I would, à la Best Horeseradishy, Best Spicy, Best Lunch in a Glass, Best Traditional, and Best French Style—the old trick of using variations of the Bloody Mary to get as many good little dive bars on the list as we could—invent new categories to make sure Made in Belfast had a permanent residency on "Best of Belfast."
MM

Sat., 1:59 a.m.
P—This is a city that has seen the very worst of the Troubles. As Dm. puts it, "There's Beirut, Bagdad, and Belfast." In between sites on the tour, he showed us photos—8 x 11 stills—"wives and sisters and mothers," Dm. says, going about their shopping on the streets while paramilitary actors raged around them. It was as if they couldn't see the war, were on neither side, wanted only peace and by being defiantly routine, defiantly normal, were going to usher in a new era by their example, another kind of picture in picture. The folks at Bittles tonight seemed to have retained that wife-sister-mother, Troubles-era resolve. But in many other spots, the virus had done what the Troubles could not, which is to scare the shit out of people and close things down (Made in Belfast one). The Ox represents a midway mindset—those who want to be brave but are about to hunker down, once the decrees are official. I suppose that these are the three ur camps, and that no matter the situation or scenario for which our tribal, sectarian, or I-don't-like-the-look-of-you conflicts get their names, we find ourselves either wholly in one of them or else on a border taking steps from one into the next. There are so many of them in the US, P, that I am more and more convinced it is space—vast, vast space and nothing more—that keeps us from warring, literally, with ourselves.
MM

Sat., 2:31 a.m.
P—Forgot to tell you: unplanned hotel stay tonight. A byproduct of the virus and the dubiousness of us getting home is that we have pulled out the plastic—not all the way, but more than we otherwise would—and are riding a sort of reserved, we'll-probably-come-out-of-this, carpe-diem wave. L. did some math, and our average per night cost still will be less than $50 US per person, even

with our not-even-close-to-the-rich-kids-of-Instagram splurges of the last two days. Only so much caution can be exercised in a situation as unprecedented as this, said with the knowing caveat that "unprecedented" has a shelf life of about a hundred years. We are travelers in foreign land hoping to get home, who have no pantry or refrigerated store of food or drink to get us through, so must venture out or rely on the kindness of strangers, on the Bittles and Oxes, even if by nature, by tribe, we'd likely follow the Made in Belfast lead. As ever, we'll see what tomorrow brings.
MM

Then slowly, as if her arrested brain had finally
started to move, she saw herself bent over a map
of the city, searching with tip of her finger for
the shortest route, as if she had two sets of eyes,
one set watching her consult the map, another
perusing the map, and working out the route.

— José Saramago

Up betimes, and all day in some little gruntings of pain, as I used to have
from winde . . . my wife very fine in a new yellow bird's-eye hood, as the
fashion is now . . . to the Rhenish winehouse at the Steelyard, and there eat
a couple of lobsters and some prawns . . . and called at the Harp and Ball,
where the mayde, Mary, is very 'formosa' . . . thence to the Coffee-house
with Creed, where I have not been in a great while, where all the newes is of
the plague growing upon us in this towne; and of remedies against it: some
saying one thing, some another . . . and to Wilkinson's for me to drink, being
troubled with winde . . . a very fine, neat French dinner, without much
cost . . . thence to the Dolphin Taverne . . . thence to the New Exchange,
and [they] would not be entreated to let us have one glasse more . . . this
day, much against my will, I did in Drury Lane see two or three houses
marked with a red cross upon the doors, and "Lord have mercy upon us"
writ there; which was a sad sight to me, being the first of the kind that, to
my remembrance, I ever saw. It put me into an ill conception of myself and
my smell, so that I was forced to buy some roll-tobacco to smell and chaw,
which took away the apprehension . . . to my great trouble, hear that the
plague is come into the City . . . and in going I saw poor Dr. Burnett's door
shut; but he hath, I hear, gained great goodwill among his neighbours; for
he discovered it himself first, and caused himself to be shut up of his own
accord: which was very handsome . . . it being late did take them to my
house to drink, and did give them some sweetmeats . . . then to prayers and
to bed . . . not to do anything suddenly, but consult my pillow upon that and
every great thing of my life, before I resolve anything in it.

— Samuel Pepys, on The Great Plague of London, 1665

Certain experts not being on the list, we perform no-longer-essential services on the fly, as DIYishly as we're able

Notes toward a pocket field guide to ice dam removal

Standing on the DO NOT STAND
 HERE top of the ladder's like

standing on a cloud. It's like being
a rock skipped across water

 during one of the stops. *The day moon*

 looks like the Death Star
 in mid-rebuild

is something I will have to remember
to remember.

 So many layovers between being airborne!

 This is an altitude
 that corrects the concavity

of my eardrums, something I've had an issue with

 since I saw on TV astronauts
 putting, on my behalf,

 an unflappable flag
 in the ash of the moon. In the not-too-distant
 distance,

 fenders and glass and whatnot
 in the salvage yard

glint like a pod of sequins
that have beached themselves

 after dreaming of houndstooth,

like an installation
I need this vantage point

to name. I climb

higher than the ladder, empty
 a bag of salt,

 like someone feeding chickens. I reach
 precariously

 in order to chip a trough

 for the melt to run through,
 like I'm a ship

 leading a way. The shingles

are very much like districts, parishes,
 counties, townships. I hold

 a granule, a displaced resident of one of the shingles,
 between my fingers, the way

 a researcher tries to put a face
 on those whom his life's

 work may save. I'm going

 to hang population signs. I'm

like a secretary of state
crying at taps. *How many*

 other floors are trying to make you
 think they're ceilings?

 is what an airplane shadow
 asks with its uncle's wink.

I have to mention
the permanent damage I've done
 to the gutter, which will cost

 real money to fix, and also that I dropped
my chisel, and how, hot from my hand,

 it sunk to the bottom of a snowdrift.

 It was like my best ideas.

"I'll have to find it come spring,"
 or something as ho-hum as that,

 are the words that led to the last
 condensed cloud of breath I emitted,
 a sad signal,

 before descending,

 as from the respiratory system
 of the frozen corpse that the rest

of the expedition discussed
like what it was, a logistical conundrum.

 Which is why they decided to leave it

 on the mountain, where,
 as on a roof,

 we busy ourselves

 swallowing and recirculating
what would be mostly run-of-the-mill

 last words. The water

is flowing. It is evidence that I have

aptitude and gall. I do not know
where I got either from.

I tell my story in lieu of references.
I am willing to be a mercenary

for your cause.

**As I support one of my favorite bars and grill, via curbside pickup,
I am thinking of the workers in mask and glove, of their fear and bravery,
and am trying to cherry-pick them, as if I were a crane on
a skyscraper's lid, placing them into what seems like serendipity**

I was once cherry-picked so,
at the Hubert Horatio Humphrey Metrodome,

 prior to it being rechristened
 Mall of America Field,

 prior to it being decommissioned,
 imploded, replaced.

Mark McGwire

 swung in concert

 with the grand prix cars
 rounding a corner outside the stadium.

The drivers chased each other
around the HHH.

 McGwire's home run swing,
 from the era of doping,

as I recall it,

 waiting now in the car queue
 for my order,

 on what I think is the street
 where home plate used to be,

sounded exactly like a formula racer.

As in an ethical case study, I was contemplating whether there be any
situation in which the risks of not wearing a mask outweigh the benefits,
when a panfish I had seen moments ago in an ice-fishing show,
while flipping channels, was something I was compelled to return to

Same way, not an hour into family vacation,
my parents would turn around when neither
remembered turning the coffee pot off.

I turn the TV back on. Look for the fish.
For the crappie with the impossibly translucent gut.

It may have had a jellyfish
as its dad. Its belly was full of what looked

like cranberry relish. What I wonder

is if, in the hope that it appeases
their harvesters, creatures harvested

during others' harvesting seasons

name the secret clubs
nobody knows about until the documentary

comes out, after their harvesters, as those of us
dying from stress

wear the logos
of our killers

on our clothes. Probably

surviving members engrave
the names of the harvested on brass plates

on memorial walls that reflect
light like a school of fish.

I have no doubt
 that on fish finders the plates show up
 amalgamated into one humongous keeper.

 I wonder very little
 about the man who caught the fish

 unless you count me wishing that the water

 and ice would switch polarity as wondering
 how well he swims.

 I want to know so much

about the crappie with the cranberry belly
I saw on TV.

 I wonder if I had gone fishing, had caught
 the crappie and found its cranberryness

 to be as illusionary as the ten pounds

 the TV adds, would I have eaten
rather than revered, in case I needed

 energy to swim?

 Crappie, my name on a plaque
 or two will be cheap at a thrift store

 once I die. I'm calling you Iris
 because I think your cranberry belly

 is really an omniscient eye. You saw me through it
 through the TV

 as I'm seeing you
 with it now. I watch as I'd watch

myself as you'd watch me die slowly

on the ice. It feels like being saved
 cryogenically, like the opposite

of being harvested, as if the harvester
 were a benevolent in disguise. I am trying

to identify three things I can permute
 and am simultaneously inventing

 a mnemonic phrase so I'll be able
 to remember them.

In a future
with a dangling and fringed sun

luring us to the horizon, as in a movie ending,
as if we were going to swallow it,

I'm giving the crappie

 a ride on my motorbike, wondering
 if it's wrapped its arms around

 my midriff more not to fall off
or more to hold on, wondering if I am not the only one

with a crush.

Mobilizing

On the home front

Those who have wondered
and worried very little

 about cows
 will be the first ones

trampled in the bovine riot.

 This is not misinformation.

 Stroking my air cow,
 I try to replicate the downward pressure

of the eleven-year-old girl
who was petting her cat,

 family members say,
 minutes before she shot herself.

Both of us stroke with the grain.

 Because I may one day be the one
 called in

to talk you off a ledge

 and into the arms
 of a past

 I make better than it was,
 as with a channel changer,

 with some café lights
 and foods we could never afford,

I'll be petting air things all day.

Because my Rotarian impulse (paternal)
is trying to out-do-good my Kiwanian one (maternal),

I must pet with both hands.

 Vicewise, I have taken up smoking
 so that hand and mouth,

 during breaks from the petting,

 can enter a kind of belle époque,
 seeing for the duration of the burn

 with the blur of invincibility,

 as we saw the wide world
 when the brain had yet to ripen,

without embarrassment
 crossing the bridge of the cigarette,

silly in love.

After deciding to go outside for the first time in days

My toes
 on the ottoman primp
 and swagger,

 as if after revolution.

They lead me from the safety of my home.

 They believe they can break the stones'
 will if not the stones themselves

when they kick them. The stones

 giggle and submit to being kicked.
 "Ah," I say,

and think of how close I am to *Aha!*

Fresh graves seen through the cemetery fence

It is as if I have come across
old public art

 commemorating what? I write
 REMEMBER in dirt with a stick,

 make of the ground a temporary plaque. I say,

"Remember me," like a bottle,
 open and sharing my vintage of CO_2,

 then make my exit,
 making this space

 like palisades, my absence a dell

through which you now must choose

 to run either rapidly
 or glassily through.

The governor says we can still go into the parks

That evergreens I like best are blue,
and in my dreams

 are the wire ends of barrel-cleaning rods

 planted in the ground,
 surplus

 after the era of guns.

 I wonder what the equivalent
 of washing the dishes to pay

for my meal is when the meal
 is the collection of observations

 gathered by the wandering self,

my ever-changing routes,
enveloping the neighborhood

 like a web.

I compare life spans and fashion decisions,

primarily with the evergreens,
who have written how many eulogies,
 do you think,

 for the deciduous trees?

I apologize to the evergreens
 in nods

 for misinterpreting
 their displays

 all winter

and earlier
in these pre-budding days

as a boast.

Still assembling
and reassembling

I take a pine cone
as souvenir

and put it into my pocket

the only way to—with
the feathery grain, else the feathery

promise or remnant or fashion or folly or reminder
of how far from T-rex we've come

will break off and leave only
nucleus, innards, marrow.

Pine cone, like you
I have been put in

and in and in
and always hope

there's a hole, and at the bottom
of the hole

another hole, and another,

after each of which I say,
By Jove,

which is not of my idiom,
but which I've accrued.

Pine cone, one of us is driver
and one of us is rider

and one of us
is seated

next to less time than others have gotten.

I'm going to turn you
and remove you

with the feathery grain
and set you somewhere

I can return to
like a shrine.

The chess of social distancing

Near what seems like game's end, my decisions collectively
have made me what scholars would call a theme.

It's as if all I've been and not been, done
 and not done, said and not said

 were a wintery landscape
 and I were living

 in a kind of exhibit
 preserved against the introduction of wind.

It's easy to see, seeing the whole of things
 preserved, how my fondness

 for rooks has cost me a heavy price
 in bishops.

That I make my king say *Gesundheit*
rather than *Oh, well*

 whenever my foe's queen sneezes
 is theme.

This morning I saw a knight's L-track in the snow.

 Before it could knock me out
 I stepped aside.

I put my rally cap on.
It, too, is part of the theme.

**Because I have the chance now, because imagination,
of late, has become my strongest muscle**

 I turn from simple euphoria
 into the very water collected

in the fill me before I'm righted,
 convex-ish, basin-ish

 tub that the seat of the metal chair
 turns into overturned. A robin, like an ingenue,

 is bathing in me. Wind and rain
 drew her bath (which I became).

I make a lifeboat-ish,

 what-about-the-rest-of-them

oasis with my two cupped hands
 because there are smaller ingenues
 wind and rain

 are never going to be drawing baths for.
My empty hands look like

 ready-to-release-a-rehabilitated-bird
 hands. The clouds reflected in the water

 I am and am creating space for
 are writing,

as if in my yearbook, that they *wish we would have
when we had the chance.*

Along the lines of the memes depicting Mother Nature doing this to thin the herd, to save the planet

When the ants invaded,
at first

>> just the herky-jerky
>> scuttlers,

>>> then
>>> the paramilitary
>>> bulb-swarmers

>> with their wings,

> via cracks in the basement

>>> that started forming
>>> if the date on the tax assessment
>>>> is correct

>> a hundred and one
>> springs ago:

I poisoned them,
and, twenty minutes closer to death myself,

>>> knelt, bare

patella to bare concrete.

**Field notes from the ecosystem "home,"
where we've been ordered under emergency powers
to shelter for three weeks, at least**

The funny feeling I'm getting
(that funny feeling we get)

 is as if a hand
 is reaching up through me,

 sympathetic or thankful,
 maybe loving,

 like a ventriloquist
 occupying

all of the empty public spaces
I'm carrying

 as if I were a post-vacation phone
 with no storage left.

 I did not know I was carrying
 so much.

I practice at reciprocating, put my hand
first through an old glove.

 To better become
 the kind of riddle we use

 to define what we can't,

I reach next
up and through
 a woodpecker,

 and I know unknowable
 solids.

I know perch, hop,
sporadic flight.

Learning from the woodpecker

makes the ground-feeding juncoes
jealous.

I will be learning new things
for a while.

If ever you
are the new owner of the closet

where I'll be scribbling
all that I learn

above the lintel,

read what I've written

about the unknowable
aloud. Run

your voice through my corpse's corpse. Learn
how mistaken I was.

**How long must it last before we return
to burying pets in our yards, our kin in family plots?**

Before the democratization
of starving yourself to nothingness,

 remember how disquieting
 it was to receive news

 of those first hunger strikes?
 Remember the sympathy pangs?

I have a story

 because a man pulled his little truck over
 and carried his little dog to the grass

 to do its business
 and then he carried the dog back to its seat
 next to him.

 They sat hip to hip,
 like an early-stage love affair

 in the days
 before seat-belt legislation.

 He carried the little dog
 because the little dog

was broken
and old.

 He put his hand through a bag
 and picked up its death shit.

Because I am letting love rule,
they drove out of my life

 different

from how they had driven into it.

Somebody else
or elses

 had to be buried
 so that there was room for them to fit

 in my limitedness.

Which of us is carrying

 and which is the carried

 and whether an ambulance
 or bed is what

 we're being carried to,

 because one of us fell asleep
on the couch or is in the midst

 of dying ourselves, is so very hard to tell
 IRL.

The world will get the news.
 The news is a child of Zeus and water.

 It will make it seem like it's not
 hard to tell at all.

After the doctor on the video consultation reviewed my symptoms and heard me cough, she said I probably have it, but there are no tests available to confirm it

Since I had her on the phone,
 I also told her

 about the pennies that bridge the spans
 inside of me where fuses

 or an up-to-code breaker box should.
I told her about the submarines.

 The submarines hunkered down.

 Once you accept the risk
 of fire, you can keep the juice

 running to all of the outlets
and power strips, my doctor said, and at that

the submarines

 surfaced and circled the oblong
 table of the tongue, as if the mouth were

 neutral territory, as if I'd turned
 off my cloaking device.

 The inhabitants of the submarines
took to sunning themselves topside.

 I was ocean and flame
 coming to room temp.

"In solidarity," I said to the cheese,
which was its own kind of manifesto,

 coming to room temp leisurely

on a plate not unlike a throne.

When the whir of art from decades, centuries, and longer ago, from times of both unease and recovery, becomes the rope thrown to those of us saying, *I'm in quicksand or mud or (what scares me most) concrete hardening*

Could it be we were born from the same stone,
from the same collision
 with water,

at the start of the same rippling,
such that today

 we are riding the wave farthest out
 from where either of us began,

 are in the same lake-plane
 surfing

on the same long board,
student and student

 chisel-thinking around what we think of
 as the same enclosed thought,

 aiming for horizons and shores,

this hand-in-hand,

 the stone-of-then
 indistinguishable from the stone-of-now,

 slingshot anew?

As doubly good as the gift of socks from Mara Mori
is the acceptance of an offer to dance at highway speeds

From the backseat
of a motor vehicle, you can look

 into the backseat
 of a different motor vehicle

and sense connection
 sensing connection.

Like seventh graders

 who only know
 how to slow dance

 one way, you can fall
 into one another, via gaze,

 like a pillar

not holding anything up. Like
the ruins

of having previously held.
A something

 assembled
 into a greatness

beyond the sum of its parts. Like

 the species of bullfrog
 that jump

 and simply never come down.

As if a great hand
were lifting you, like a marionette,

from the opera you thought

was all there was.

**As with those succumbing alone, becoming
the raw material a new world will be made from**

> I walk as if on an ice film
> over water, trying

not to fall through.

> I find the resolve
> to stand even more lightly

when I think
of what's beneath the ice film
as bottomless.

> I hear but can't see

> snow geese, their cackling
> all that's left

> of how light they've become.

A blade of grass
lifts a kernel of soil

> from the earth it grows in,
> like an offering

> to the cackling.

> I will try to get lighter still.

PRELUDE 3

Sat., 8:14 a.m., 14 MARCH 2020

P—It looks colder outside than it is, which you discover once you're out in it, a fair amount of humidity propping the temperature up, like a kind of dowel keeping open an old window where the cord has broke. We know these days well, when the cursory weather-app check has us grabbing the very flannel that stepping outdoors says to tie around our waists—which you and I did long before it was a thing the kids do, if I can sidebar. This Belfast day is like a kind of Minnesota day I love, as much for the surprise as for the damp envelope of warmth that gets one thinking one might, molecule by molecule, expand and become the very day itself. I do not believe in signs from the universe—from god, angel, demon, alien, or otherwise—but it nonetheless feels as if there is a prompter offstage giving us and the day lines from a script the gist of which is that there are better days ahead.
MM

Sat., 9:17 a.m.

P—The bus stop where we were first dropped into Belfast is the bus stop from which we will depart, one of the many circles we're making full, only now it's not the foreign flower we were dropped into and left to figure out our bearings, but is a familiar aspect of the mise-en-scéne we've constructed here—our flower, our little garden. The driver is as efficient as a machine, arriving with just enough time to open the cargo hold, check tickets, have a smoke, and depart on time, a Swiss watch transformed to ferry us. We learned on the two-hour ride here that the bus has no toilet, so this morning I have been on a liquid fast, save for the hotel-room variety of caffeine very early (plus I inhabited one of the habits of my Greatest Generation grandfather, taking a tug from the bottle of 12-year-old reserve I got from Bushmills, which you can only get there, they say). If the next time the road to Belfast starts in Dublin, I'll take the train, I think, if it has a lounge car and a loo. This bus will make rail coach seem like the old First Class, though of that I know only by hearsay.
MM

Sat., 10:11 a.m.

P—The kind of morning cough one uses to clear the throat has become a casualty of common decency, and common decency seems to be the suddenly and universally adopted comportment, as if the virus were a tool of our too-long dormant manners. There are a few

mask-wearers, and all conversations—save for a carbonated one a couple of English girls are having as they engage the outside world, able to get signals on their phones (I have learned from them that SXSW is canceled)—are subdued, as if we are all from the era bygone when *cancer* wasn't said above a whisper. I am breathing—how to say this—reservedly, like one on the way to death, barely taking in and barely letting out, what is usually involuntary now monitored and regulated, like a movement at tipping point, as if by doing so I can create a bubble I'm safer within.

MM

Sat., 10:29 a.m.

P—I had been looking out the window at the Irish landscape, which is as uniform by now and with as little new to see anymore as fields in farmland or pines in the north. A. was napping when the driver pulled fast to a small roadside parking area. I thought at first that perhaps his bladder had gotten the best of him, that he wasn't as Swiss-made as I'd presumed, but then we were boarded by two Republic of Ireland police, Gardaí. They said we must produce identification, the lot of us. A. and I had our passports. D. and L., in the seats ahead of us, had packed theirs in their bags, which were in the cargo hold. The police rather reluctantly accepted their Minnesota driver's licenses after they'd offered to get out and unpack, standing up to show they meant it. On the way into Northern Ireland, I missed the "Welcome to" sign, if they do those here, but knew we had crossed the border, as the Irish Gaelic that had accompanied the English on the road signs was no more, not once we had crossed into her majesty's domain. It is hard to imagine Brexit, once it's all resolved, not resulting in either a full-stop border or a reunified Ireland, if this is any taste, which is what my mind's tongue tells me it is. Though we had committed no crime, I felt we would soon be in search of a dinghy we could row to Instanbul before walking to the safety of a consulate in Greece, à la *Midnight Express*. Just for the accusation, just from the act of being boarded, I felt convicted.

MM

Sat., 11:44 a.m.

P—We arrived at the only hotel we had planned to stay at—a good bed for our last night here—in what seems to be the oldest part of the small medieval enclave (there are many historical signs) turned into the Dublin suburb of Swords, too early to check in, but the hotel

will keep our bags for us if we care to wander about, making us a bit like refugees in training. What we need to do is eat, which we have not (save for hotel snacks) since The Ox. In addition to the signs reminding us to wash our hands to contain the spread of the virus, which we first encountered in Derry and were hung on the front and toilet doors of every operating establishment in Belfast, we now have gloved workers and hand-sanitizing stations at entrances and exits. Had there been a warehouse full of such stations run by some prescient amateur epidemiologist? The original plan was to take the train into Dublin today, but we are told that it is shut down save for the rogue pub or two—that we would be riding into a city closed, its public spaces vacant, ambushers with bad scouting reports. They say that Swords will soon follow suit. I feel like Butch and Sundance deciding that Australia or New Zealand is the place we really ought to be. We still hope it is our last night here.
MM

Sat., 12:01 p.m.
P—We arrived at a largish pub, more suburban in decor than not (you'd agree), though comfortable—called the Old School House after what it had been, the naming of the thing suburban too. I got an Irish coffee that the bartender claimed as a specialty. It more than made up for the lack of a normal dose of caffeine, for the willful dehydration of the bus trip. I also got a Carlsberg so that I would not feel hungry—the old trick—as it would be about "twenty or thirty" before the kitchen was fired up. The bartender readied his station and kept us—his only table—in pints and coffees, like a scene waiting for the night to Hopperize it. Aer Lingus now says to arrive four hours prior to departure, that our flight is still a go. Servers and the like keep coming in one by one and easily outnumber the patrons by treble (there are two confirmed couples outside of our foursome, arrived after us, but otherwise we've got the School House to ourselves, like the private-school set). We struck up a conversation with a server who thumbed us to look over his shoulder, where a group of men in a separate dining area (there are cubbies and corridors in abundance—a good place to play hide-and-seek), in the blue-jeans-are-okay version of business casual, talked at a low level of animation, like gangsters who know their gig is up, no amusement fermenting the air between them. They were the owners, deciding what to do next. The server said the School House would normally be

packed by now, people here to drink and watch games on the TVs in the big room. He said he didn't think he'd have a job tomorrow.
MM

Sat., 4:11 p.m.
P—We walked around the local castle and round tower—got our passerby dose of history—and settled like sailors with a pass into a dark old place called The Attic Bar, full rather prominently of older men watching steeplechase, which is a thing here, especially this time of year, a major race festival happening, I think in England, on the televisions. You can tell upon which horse the patrons have or have not placed wages by the cheering or dearth thereof at the close of each race. It is not unlike our March Madness, and has been a regular feature in a number of pubs and bars in the villages on the road, although not so much in the cities. D. and A. and I sat at a small table, as did one other couple—an older man and his wife—two tables of interlopers among the gamblers, as if we had on reflective vests, the regulars all seated at the bar or at high-tops close to it, engaged in banter and jokes that only needed to be spoken a bit louder than the norm, not yelled out, the quarters were that cozy. I feel very much like Mac when he first tries to insert himself as a friendly among the good people of Ferness in *Local Hero*. I would feel even more so were I A., at whose behest we headed out after only two rounds, leaving the woman at the other table as the last vestige of femininity in what amounts to a boy's locker room.
MM

Sat., 5:25 p.m.
P—In a packed Cock Tavern—Macs, all of us, who with a sense like sonar have found each other here—we snagged a small place for two, taking turns being the stander as we watched a bartender help a couple find something they'd lost in the behind-the-scenes gap between the wall-mounted table and the wall itself. The Attic and Cock claim to be nearly as old as the castle and round tower, are wood over stone, prone to gaps and, one posits, secret passageways and walls that are doors if you remove the right book. It is part of the charm. We watched as various tools of mixology were repurposed, this and that piece and panel removed—like getting at the heart of a new kind of fruit—and discovered that what the young man had lost in the gap was his phone. Our guess had been a credit card. Were

this the end of a steeplechase, our groans would have given our poor prognostication away.
MM

Sat., 10:41 p.m.
P—Before dinner, we watched Irish TV from our hotel beds. I flipped back and forth between one channel that had on something rugby-ish, with a full, cheering crowd, and obviously a rerun, all such gathering being banned now, and another channel playing reruns of the 1970s shows we'd watch after school. The Irish have told us that they understand our accents perfectly due to their diet of American TV. On the contrary, I have wished that more than one conversation this week had come with subtitles. L. and I sipped some of the good Bushmills I hope we can finish before morning, lest I'm forced to seek a grave to pour it over, as it shan't go down a drain. The dinner scene at the Old School House was opposite of what we experienced at lunch, the other side of its coin. A theory is that the lunch crowd is traditionally locals, and what has packed the place tonight, as at the Cock, are sundry Macs. As theories go it's a good one, given that it's the only one. It feels as if we are part of a great surge amassing and about to wedge our collective way through a bottleneck at the airport. The Trump deadline to travel from Europe to the US has passed and the new ban on travel from Ireland and the UK is looming. This is the 48 hours between them at one of the last gateways to home.
MM

Sat., 11:31 p.m.
P—Patrons at the School House tonight were au naturel—no masks or gloves. But where would we get them? Few if any of us being local (and the local supply likely already hoarded), what choice do we have but to expose ourselves to each other's air, wash our hands like squirrels, and remain as calm as we can be in our common fate? How many throughout history have huddled so, understanding to the quick why we have the word *fate* at all? When a woman with a man in one of the booths of our cave-ish cubby—which struck me as not unlike a dining car—coughed, every one of us heard it like we hear tornado sirens at home, seated in its wash of warning with no access to basement, cellar, or unwindowed interior room. It was like a Reznor soundtrack to accompany either our imminent demise or miraculous survival against the odds.
MM

Sat., 11:44 p.m.

P—I forgot to tell you about the strangest exchange of all, one that perhaps foreshadows the two sides we'll have to choose between when not in the suspended animation that the current conditions have we travelers, trying to get from continent to continent, over an ocean, in. I feel like not much more than iterations of Mendes's famous plastic bag, whose ballet is a function not of agency but of the winds of the moment. The luxury of choice in matters beyond whether I get a burger or fish, a Carlsberg or a Guinness, is largely not ours. So this fellow, a local I presume—and perhaps one not at all amused by the throngs of foreigners from virus hotspots populating his suburb like a festival crowd unconcerned about who cleans up the trash it leaves in its wake—said something to our little group of four on our way into the Old School House for that final meal, that fattening up for the journey ahead. And I couldn't make out what he said through his accent. I have generally found here that a stranger having something to say is an exchange worth the make. There's good advice, guidance, and humor to be got for free. It's not at all like at home, where the unsolicited exchange is best ignored if not preempted by averting the eyes. Each time I said *Pardon me?* the young man got closer, as if my inability to get what he was getting at were the result of proximity, how its reduction increases the volume in the ear. By the time I could make out the English via the Irish, he was within the range one needs for seduction by tongue. And what he said, more and more adamantly, was *you can get it there—don't go in—don't think you can't—it's not safe—washing your hands won't stop it—not in that crowd.* Irony's halo was the atmosphere under which we breathed in and out, after we were finally able to communicate. WSWTB, my friend.

MM

And since life returns to normal even after the most singular events, those who had emerged from the sea of fog began to order their drinks or their food.

— Marcel Proust

Chicago looks as tho it has got one foot in the grave & the other on a banana pealing. Everything is closed on account of that epidemic. Dances, Theatres & all other places of amusements. Evening schools are closed. No smoking whatever on car. If you cough continuously at work, your employers are compelled to send you home. I tell you, its awful. Numbers of people die every day.

— Clara Wrasse, on the Spanish flu, 1918

Now that we know our hands are sacred texts

*The water in which you soak them will also serve to cook them,
and whatever remains from the cooking will cease to be water,
but will have become broth.*

— José Saramago

In a premonition of me
 in my *speaking as an elder*
 stage, I am assigned

 to the back of a hand
 held against a brow,

its skin and bone span
 telling a fairy tale
 about the old days of sun

to all in the shade who'll listen.

 I stiff-stand, an antenna
 awash in light,

feeding what I know
 to the storytelling brow.

 The eyes, awash with listening,
 are a color they've never been.

The eyes are seeing everything
as a god deeming good

 its realm.

When I think of myself
as the things I've said

 prior to entering
 my *speaking as an elder* stage,

I stumble as if being passed
from cupped-to-drink-water hands

cupping me carefully

to someone thirstier
than they are.

Old holder, remember our time together
like a style of shoe

we all had to have in our youth.

I am passed from nursing hands
 to ecosystem-ing hands

 like pollen on the legs of bees.

I am always stumbling
as if I have never not been drunk!

I am hoping

 to settle on the hands
 in which I am a style of shoe

come back to popularity again.

 As if bathing
 in the extract of old fondling.

 As if the slow dying
 off of the nunnery could be stayed
by licking the tears-like-paper skin
 of old hands.

 I am a song
 with its best verse dropped, watching

 from a cell I'm free to leave.

When I inhabited the body of bird, I felt
 lucky—at 3:30 a.m.—to be wheedling

back from the other side of the world
not the sun

 but a fool's memory of it.

The tiny hands
at the ends of my hairs

 simmer and reduce

 until their potency
 is coveted.

 There will be no need
 to steady them

to join the hands at the ends
of other hairs

 when we enjoin
 the days

 of no delicacy at all.

 When juggling

becomes its okay
to squeeze too hard,

 we will no longer want
 what we pass hand to hand

to be washed away.

 When you were twenty-two
 you did not yet think

of corpse hands.

You did think that hands
knew patience.

Now we have hands like fairgrounds
no longer in use.

We have the hands of the young

in their swimsuits raising money

unbeknownst in the hands of the old movement
that gave everybody Saturday off.

I have been on hands that don't honk,
not even courteously tap-tapping
when one is on one's phone

when the light turns green,

when the light turns red,

and we have to wait for it to change again.
Our hands can start a movement.

Imagine all the people in all the homes

in all the land cheering,

en masse but not,
watching on TV

news that our hands are free.

Hand in the style of doo-wop
or scat.

What a hand smothers

can never be scrubbed
out of its grooves. Open-

fingered hands that hit by sticks
do what cymbals

 do for a song.

Mud-nesting hands
with a little steady rain

can so easily become
a mudslide.

 Day of windows down,
 continuing to learn the unwritten

laws by breaking them accidentally
 and receiving summonses.

 Hands like a student getting expelled
 to make a point, trying

to be something another can learn from.

 The tourists
 gather around what they think
 are celebrity hands.

What a day

 day! Like riding hands
 signing Japanese

to a whale.

 Hands like Muses
 doing mortals, making halfies,

 the halfies make quarteries, etcetera.

Oh go put your hands in fire
if they're not already aflame.

Singing off each week,
Dr. Arne Vainio

says that your elders
are waiting for your call.

You should know the number by heart.

We have graduated summa cum laude
from their obedience schools

We on a leash
 know we are on a leash
 but do not know

 who's walking us through the fog,
 the fog's

that thick, the leash is
that long,

 our rooms too nice
 to believe

we're choke-chained.
In the civil disobedience style,

 we might yet chew
 through the nylon or leather,
 the reflective coating,

and be free.

 I feel like I have been cast
 like bait into a sea,

 that the leash is that long
 and translucent.

 Like a lure,
 I'm playing my tiny gong,

my heart being tied
to the end of a mallet.

 A tree
 drawing water

up through the rivulets
in its trunk

 is fighting like Rachel Carson
 to be heard

as I am fighting
like Gertrude Stein. I follow

 the water up the tree,
 like an empty barge

 on the way to pick up freight.

 I am hoping that today
 is the day I snag the leash.

The world is full of such hope
as this little one of mine.

No matter whether or not you hear the wishing

What was

 new from the headwaters
looked like the old flow, i.e.,

 the river never said very much.
 I made a wish

 and threw a small rock.
 Every time I threw a rock

 I envisioned mathematical equations,
 their neutrality

 resetting things
 like a ceasefire.

 They were the skeletons

 to which my wishes added flesh
 and organs.

It is one way to begin
to solve the problems of this world.

 To throw my small rocks,

 I stood on a single giant rock
 the late Pleistocene left behind.

 I called the rock shelf I stood on
 the rock of futility.

 I was told
 it was called the rock of futility

by one who gave up wishing
before me.

The waterfall
that spilled out of the giant rock

was taking advantage
of the rains

and so had much more to say
than the river.

"Plunk,"
is about all the river

had to say
regarding my wishes.

Only I, perhaps, heard it speaking.

Chernobyl is a lobby
with no roof, a city

Homo sapiens left behind.

It demonstrates,
like a small-scale reproduction,

what the glacial, over time,
can do.

**As with the unsolicited nude quarantine selfies
that the NYT reports are all the rage**

From a memory of play, in the light of day,
 I'm cutting out a field
 of dandelions waving,

 as if signaling from undersea.
 I'm careful to curve the scissors
delicately around the stave-ish
 petals.

 How savage,
 with no anesthesia,

to cut things from your head!

 I glue the field (I was
 a lifeguard) onto a memory

 of an overcast autumn.

 Hey, we're splashes of light!
 is what the stars say

of my version of themselves
in my version of reflective glass.

 Hey, we are!
 is what I say back

 to them and you
 who have gotten not

what you wanted—
the dream of jet-packing over it all—

 but this invitation
 to play some more.

Why I have volunteered to be a contact tracer

I thought
 what I'd done right before bed

 was kill an invading ant. When

 the following day
 was writing out its grocery list, I saw

that what I'd actually done
was make the ant suffer

 through the night.

I don't swim
like a fish nor sing like a bird, not
 even starlings or carps.

 All of my appendages are intact.
 Mole, you are not a mole,
 but a planet with a fiery core

 covered by water
 too something-or-other

 to drink.
 At my dissection

among the things they may discover

 is that I wanted to be the silver cup
 on your dresser,

 the keeper
 of treasured things.

The forensic specialist
will show that I did not want
to be your treasure per se.

 Just the cup.

When ours is the niche practice that the human-interest reporters use as the du jour lens of oddity, via which the foibles of others in comparison seem like normal reactions

Research on writers appearing at the Edinburgh international book festival reveals 63% listen to their creations, and 61% feel they have their own agency. 56% of the writers surveyed reported visual or other sensory experiences of their characters when they were writing, while a fifth had the sense that their character was occupying the same physical space. Fifteen per cent of writers said they could even enter a dialogue with their creations.

"When I'm trying to 'put words in their mouth' instead of listening they often talk back. And then we discuss things until I find what they would say," reported one anonymous respondent.

"Hearing voices and other unusual experiences are not in themselves a symptom of a mental health problem," researchers wrote.

— The Guardian, April 2020

We have always known
 that we're vulnerable

where our kind of forest
meets their kind of field.

 There is so much fecundity
 at the edges.

There is fecundity
even where curb meets road.

 The stands like deer stands
 above our sight level

have been there all along.

 Those who would eat
 the jerky or mount the trophy
 of us

are seeking
untranslatable rarity,

like investors in a foreign-language film,

abridging us in English
until we're cartoonish. You

a you-skin rug in one room, me
a me-skin rug in another,

dogs' and cats' feet
ferrying our letters back and forth.

How to make sense of an ending
where we subsist on an almond a day?

See how we stir

our fingers in the air
we're about to breathe

as a vineyard owner
might do?

We are colliding like this

because a switch was flipped
and the escarpments

that we were at the edge of

left us backpedalling,

the fossilized brachiosaurus's
fuck-me-my-brain's-in-my-tail

look on our faces,
wishing

our tongues were wetter,
that our fingers

could not only read the winds
but speak their language, too.

As if I had been visited by bees

The veteran garbage man
trains in, with aplomb,

 a new hire.

Rendered in pencil,
 it could be called

 Necessary Work.
 It could be called
 Study in the Acquisition of Grace.

 One
 demonstrates, another
tries to replicate,

 as if learning
 the steps of a dance.

 I moved
 like I'm moved

 by the occasional and well-conceived
dramatic episode in a serial comedy.

 Before I was moved I was
 repeating a phrase.

My new mission is reconciling.
My new mission is reconciling.

 Now that I've been moved?

 I'm trying to flower.

May they not know all we've pretended

It was like reading about
 somebody else doing it. I dropped

 the bar of soap with the one
 lathering hand, caught it with another

ready-to-lather hand, both
 dropped and caught before
 I'd realized I'd done either, as if

 I had not hands but Wallendas, as

if the soap were a migrant

 nephew learning the family trade.
 It was like reading a coming-of-age

 tale, proud independence
 and daring in all of my extremities,

as if all along I were a circus
 and had not known it

 living a life in a time
 of circus's dying out.

It was like reading a coming-of-age tale
having never come of age yourself.

As I was stringing the high wire,

 I imagined a calendar and the days

 of practice I would need. In the future
 I would see more clearly:

 that from wire-walking stuff
 I am not cut.

But because it wasn't the future yet
I said, "Ta-da!"

when I caught the soap,
and I struck a victory pose

 and turned to acknowledge the applause
 in a big top

of my own invention.

The friable quality

I smile as I verify
that my driver's license

 shows that I checked
 the organ donor box,

thinking of my eye

 in your socket looking back
 on a past that imagined us
 inside each other more wholly.

I almost die from the joy, seeing
like elders whose advice-to-the-young

 eye sees by standing atop a pyramid

 the elders didn't know, until they were too old
to climb back down, that they had never been paid to build.

Our futures

 are futures of walking multitudinously,
part butcher, part cobbler, part Hindu,

 seeing the same cow.

 We make more and more sandwiches
 for all the unexpected visitors

drawn—they know not why or how—

to our kitchen of nearly fatal joy
 with bread we were saving for another use.

 If you like flags, wave us. Sing
 to honor the (many just now)

dead. The dying. The air
 that has ensnared us in its web
 is wrinkled and corrugated

 and wavy in the wake of Romeo

Romeo-ing it, Juliet juggling
 us like her offspring in the inflatable

 bounce-house of her mouth.
 What a blast,

riding words time-released to self-destruct in a kiss, breaths
 breathed out like prescriptions

 to heal, as if the tongues
 were picks, the tongued guitars,

 such that we almost
 miss that we have maybe sixty seconds left

before the future is what was meant
 to be.

**The charm of happy-houring with the ghost of Mike Wilson
is that what appears to others as overly animated talking-to-myself
is in these times accepted as a perfectly normal thing to do**

*May Day 2020, 5:30 p.m.,
from a chair in the front yard,
in solidarity with the Amazon
and other essential workers
out on strike.*

The sun reflects rapid-fire

off the 18 bus, its
windows like a geode

sending a message
we decipher

as a new strain of joy, as

*If every time I have something in my shoe
I think of the something as you,*

annoyance will become delight!

The smokestacks
along the river exhale

what those downriver
sit beneath,

waiting for rain. We belch, thinking

some subset of someones
somewhere will sit beneath

an us that is also a not-us

waiting for what they need.

The fitted sheet holds its tongue.
The free sheet thinks they're equals.

Decipher that!

Our stories
were already so poorly dubbed.

Our beautiful eyes
will forgive them for staring

at our beautiful lips.

We will never be folded and fresh in
the same linen closet again

unless our reflex reaction
to sit as far away from the table

where the cops are as we can

puts us there
serendipitously.

The road between us
has yet to close.

We must hold each other up

horizontally to gauge our growth

against the trophy fish
on the wall.

It will feel like we have been growing
in the wrong direction all along.

We are a river
that looks like the idea of flowing water

even after the freeze.

One day we eat our eggs
as we like them, not knowing

the other has died.

Are we dissolving

like an effervescing tablet
in a glass

that anyone who wants us
to teach them

can drink?

When these glass swans we're riding
break beneath us,

like a sun shower
we'll make better where we're flying over

as faces are made better with glint.

Until then,
our shadows show us riding too hard,

embodiments of the secrets we keep
on how to glue things together again.

PRELUDE 4

Sun., 7:34 a.m., 15 MARCH 2020

P—It is sunny and warm, like the weather that they say lingered here the week before we arrived, a kind of ghost sighting. I have just spent a full five minutes wondering what one who believes the outcomes of a day are the result of being in either the favor or disfavor of a god would do with this news. I put myself in their shoes to take stock of who I am by trying out who I might otherwise be. Had to leave a dram of the Bushmills in the room, as we aren't checking bags, although I believe what's left is under three ounces, and I was tempted to try to bring it on with me, muling it. There was enough time, really, that I could have finished it in the cab. Such clarity of hindsight must mean I'm worshipping the wrong things.
MM

Sun., 8:46 a.m.

P—There is a strange kind of situational déjà vu in the airport, having entered into the same atrium where we exited eight days ago, getting a cup of coffee from the same vendor—another Caffé Nero—though as far as déjà vu scenarios go, there is a dystopian tinge to the here and now, the old bright painting restored by a dark visionary. None of the tables at the Nero are open for seating, all the chairs upside down upon them, as at closing time, when such a rearrangement gives the broom or mop space for its solo. The barista (not called a barista) is gloved, the atrium seeming to have been rezoned in order to save the echo, as if it were now an endangered species.
MM

Sun., 9:00 a.m.

P—Making our way to check in, we have found where all the people are, made into a kind of coiled rattlesnake by the maze made by the stanchions and their now-and-again-loyalist retractable belts, although it is a rattler whose rattle itself—the part of it outside the stanchions and belts—is growing longer and longer, heavier and heavier, such that the snake may tip if they let in the Dublin breezes.
MM

Sun., 9:17 a.m.

P—Having got to the end of the rattle, the gentleman shepherding us is asking where we've been. Those like us who have not left the island are sent to a shorter but slower-moving line, parallel to the snake, like the edge of a box it's inside of. Those who've come from a

Schengen country are routed to the rattler itself. For all the people, you would expect more noise. Instead we are more similar to bees in a hive, fixated on the mission, our collective hum never rising to a din. Which means you can hear the answers of those ahead of you in the queue, see that there is no verification required beyond one's good word. I do not doubt that the answer for many is honest. Nonetheless, the faster speed of the longer line makes our shorter line less enviable than it could otherwise be.
MM

Sun., 9:39 a.m.
P—There are many young people here with us—students, it seems, returning from spring break (those with backpacks) or from truncated study abroad (those with today's wheeled and many-pocketed version of a travel trunk or two). It's impossible to not overhear conversations, all of them held in New World English, the accents like the smell of a particular family's home, immediately recognizable on goods they have brought out from it. A young man we are shoulder to shoulder with at intervals, as we make our serpentine ways through the innards of the greater snake we make together, is coming from Spain and was just yesterday with friends come from Italy. His friends say they are sure they have already had the virus, and he is equally sure he has been exposed. As in any belly, what was discrete or served in courses is mingled into a single mass for either digestion and later excretion, or for vomiting.
MM

Sun., 9:55 a.m.
P—One boy just ahead of us has on a Twins cap and has repeatedly told anybody who will listen—and the faeries in the air—that he is just trying to get back to Minnesota, is just trying to get back to Minnesota, is just trying to get back to Minnesota. He has repeatedly said a few things many times and again, his sayings accompanied by all the outward signs of an anxiety that barely caps his percolating fear, if you'll allow me to read him as a geologist does an idle, but signaling, geyser. He needs, and receives, continual assurance that he is in the right line, that he will get to his gate, that things are proceeding as they must, as well, under the glut and deadline, as they can, not unlike a new kindergartener being gently coached for day one. When we are questioned again by one of the Aer Lingus shepherds, we find that we are in the line for those who must go to a

different hub than they are scheduled to return to, based on transfers, layovers, and the new rules of the virus. We are not moved to the end of the long snake but are inserted into it where a break has occurred perpendicular to us, due to a slowdown at the base of the rattle— some confusion, it seems, over the questioning and line designating that got us in the wrong spot in the first place. This, of course, has increased the boy's anxiety, further cementing in him the notion that he is in the wrong place to get him where he needs to go. He is the only one among the hundreds and hundreds of us (thousands?) showing any outward sign of unease. Were this the wild, he would be the one plucked by the predator a link higher than we on the food chain, our natural camouflage having saved the rest of us, we'll think, as he is torn apart and devoured by claw, jaw, or beak.
MM

Sun., 10:30 a.m.
P—Dublin, D. and L. say, is one of a baker's dozen or so airports in the world where US Customs occurs here and not in the airport of destination, which is MSP for us. We got our boarding passes, made our way out of the rattler's mouth, took a quick respite in the toilets before what D. and L. said were multiple queues ahead. I have not played D&D, though feel my story is less mine that than of some unseen Dungeon Master. The first next queue we encountered was a queue for standard security screening, the X-raying of the bodies and bags. We then arrived earlier than scheduled at the queue for US security screening. The signage said that, given our departure time, we were not to queue up for another hour yet. We ignored it, got into another maze of stanchions and belts, became faces in the crowd in the backgrounds of photos those who hold their phones high take to share with a curious world, which is akin to being a pixel. Standing out as we weave our ways through—at a slow but steady-enough-to-make-one-hopeful pace—are the handful of us (we are an "us" now) wearing masks. And it is only a handful, and as they reappear either in the row next to us or various numbers of rows away, I wonder where they got them. Where were they that a supply was available for purchase? Several of the students we've struck up conversations with are on their phones, texting friends ahead of them in line, who have been waiting for three hours longer than us, and are still waiting, like ancestors risen from their graves to warn. It is hard to see what sort of adventure awaits. This queue leads to stairs and an escalator going down, the airport shepherds letting, now and again, a handful

through as they peer down and speak into walkie-talkies, managing our flow, not unlike things in the process of assembly or disassembly in a factory's or abattoir's line. Another student, with her boyfriend, has discovered she has a name other than hers printed on her boarding pass. I speculate with A. in whispers about the trials ahead for not just her, but for the person whose name is on the pass. It is as if their drama were ours.

MM

Sun., 11:00 a.m.
P—The line has stopped moving. Our walkie-talkie shepherds have been joined by other agents in different uniforms, coming up the stairs to consult with them, the end result being no more handfuls of us are allowed to descend. Too much gristle in a gear. Those texting their friends relay that everybody ahead of us is sitting on the floor. There is speculation that they are getting their temperature taken, that someone has come up positive, this current delay resulting from a full-scale disinfecting. The shepherds, all gloved, have placed cases of bottled water at intervals throughout the queue, free for the taking, a gesture I cannot fathom being replicated in the States. It feels like a trick—bait in a trap. Several of us have turned our bags into seats or have decided the floor is clean enough, like frogs acknowledging that the water is warmer, sure, but not too much. This indefiniteness is for some—myself included—a chance to duck out of line, use the toilet, returning to a somebody saving our place.

MM

Sun., 11:11 a.m.
P—I am very much appreciative of the egalitarian nature of our shepherds. A goodly number of travelers, joining us from queues past, see the length of the current queue, that it is stalled, then proceed to waive their boarding passes, exclaiming their impending departure times, seeking dispensation from the wait that the rest of us continue to, very peaceably (despite the increasing physical discomfort), take as part and parcel of our lot. All that the shepherds offer them is the comfort of the fact that the airlines all know of the delays. They continue to add stanchions and belts to corral the incoming wave. Cliché as it is, "petri dish" is on the tip of my tongue, and I have to believe on the tips of hundreds of others. And like, I imagine, microorganisms culturing in an actual one, this all seems like the kind of reality I hope to wake from, a wakening which reveals it to be

dream and next instills such a deep distrust in the senses that never again can I be sure anything is real, or for what reason we even have that word.
MM

Sun., 12:15 p.m.
P—Obscured until one is near the end of this queue are three ticketing stations where we have to produce our boarding passes and answer again to the countries we have been to. How many, I wonder, are denying for a second time recent travel in the Schengens? Here is where the student with the stranger's name on her ticket stalls the line behind her (happily not the one we are in—her drama and that of the stranger on her ticket, for us, like an unfinished novel now). It is possible to simultaneously feel great empathy and also a gratitude for one's own good fortune at having what is routine be routine. After getting through the ticket check, we finally descend the stairs, feeling hundreds of pairs of eyes wishing they were us, like hands upon one's back, clawing to hitch a ride. It is like walking a red carpet the afternoon of an awards show. We have, it seems, been handed off from Ireland to the US. A. has struck up a conversation with a young girl, who, although traveling alone, has the air of a seasoned traveler, as do so many of the students, which is all it takes to re-steep me, the experiential disparities provided to the wealthy youth reminding me again of my place, of all the disparities that begin blossoming at birth. One is lucky, to be sure, to be born, but to whom, where, and when is the thing that determines so much. I think *the girl is very nice, articulate, funny even, and not herself to blame for systematic disparities,* ever the softy.
MM

Sun., 12:24 p.m.
P—Although I come from a family and family tradition where the vacations were irregular, not annual, but always taken by car, lasting a week (all that our dads could get off work), another few days in the summer reserved for camping in a state park, I find myself reliving, here in line, a trip I took when I was this girl's age, yet was such a different sort of creature than she, as different as a starling is from an oriole. You may not know this. I had written an essay with a 750-word limit in response to the question, *Why Is Wetland Habitat a Valuable Natural Resource?* I thought hard about it, wrote a longhand draft in too-thick pencil, shared it with my elementary schoolteacher

uncle and aunt, applied their advice and my own rethinking in a final draft written in more-official, somewhat lighter pencil, folded it to fit a business-sized envelope, and mailed it in. I did not know what I was doing, but like a homeowner trying to save cash by being one's own handyperson, I was resolved. I was winging it, and not for the last time. Had my essay not been selected as one of the two winning responses from the Mississippi flyway, and had I not on the heels of it been fêted—dinners, gifts, and the trip I am getting to—in return for short speeches in small rooms of what felt like fans, a kind of coronation after the fact, I do not know what, if anything else, would have said to me, *Perhaps you can carve out something, some semblance of a future with this writing thing?*
MM

Sun., 12:37 p.m.
P—The contest judges selected two winning essays from each of the flyways in the US, and we joined four winners from across Canada and two from Mexico in Canada—Calgary—for a week of festivities that included the capture and banding of molting Canada geese. It is the getting there that comes back most vividly now, traveling alone by air as a teenager who had never done so and coming from a family with little to offer by way of advice, an orphan in a banker's house with no swell musical score to show the way. I was out of my element, faking any outward display of intestinal fortitude. During a layover in the airport in Denver, a nice-seeming gentleman approached me. He reached out, shook my hand, treated me like an adult. The man appealed to my sense of what is good and right, offered me a book, and after it was in my hands asked for a donation. I had no money to donate, was on a budget with no wiggle room, felt suddenly as though I had been taken—that his kindness was the charade of a pickpocket and now my wallet was gone—and tried to give the book back. But the man insisted I keep it. He left, I paged through the book, found it was a Hare Krishna screed. I was convinced I had nearly been abducted—it was the era of the Moonies—and vowed to fake my travel chops even more resolutely, taking away from the essay contest not only that maybe I can write a bit but also that eye contact with strangers in air hubs is to be avoided at all costs. As if a new thing has been discovered by the physicists that changes everything, that habit has finally and alas been eradicated here.
MM

Sun., 12:44 p.m.

P—On the drive from Derry back to Belfast we strayed off the direct route to spend an hour at the Ulster American Folk Fair. It is a kind of open-air museum that D. and L. say are fairly common in Europe, and of which D. is a fan. Worthington's Pioneer Village, which probably you don't know, is the only similar thing I have been to. In Derry, when D. told G. of our plans to visit the fair, G. cautioned that the treatment of the famine-related emigration of the Irish to the States was heavily whitewashed, making no mention of the fact that the Brits continued not only to export but to increase exports of Irish foodstuffs while the mostly Catholic tenant farmers starved. G. said that the fair also greatly underplays the suffering and horrors of what one had to do to secure a place in steerage, and of the journey itself. I vividly recalled G.'s framing of the fair—like Blake or Ginsburg having a vision—when our guide, in period costume, showed us the quarters populated with happy-ish mannequins on the replica ship, and even more vividly am both there and in G.'s rendition of the truth right now, all of us hubbed like this and thankful for it, and about to spin off in as many directions as there are beating hearts, as if off of a great wheel of fortune, whether into windfall, affliction, plenty, or penury, none of us know or care, as long as what's next retains the beating heart. How Dreiser's Carrie got from Wisconsin's hinterlands to one height in Chicago and a second height of an entirely different flavor in NYC, moth to flaming it through Minnie, Sven, Drouet, and Hurstwood—and Hurstwood's decline to final darkness—is no longer so fictive. I am hoping that my little aptitude for poetry, which brings neither wealth nor fame, saves me from Dreiser's theme of themes, my otherwise inconsequential island of delusion good for that at least.
MM

Sun., 12:53 p.m.

P—The only air travel my parents ever made was also the result of a contest, theirs having to do with success at commerce rather than a young duck hunter's attempt at environmentally based persuasion, the ulterior motive of which was a good stock of game. The shop that my dad worked at, under and then with his own dad, who started it up in small-town Iowa in 1938, had sold enough Goodyear radials, fitted to cars, semis, and tractors, to win an all-expense's-paid trip to Vienna, a perk from which they returned with gifts (a replica sword for me with a plastic safety guard over its authentically sharp tip)

and slides they narrated like tag-team Rick Steves, improving on the show (I saw every episode) for each pod of guests who viewed it on the screen set up in the living room. Literally the vacation of a lifetime, they never flew again, save for a solo trip my mother took with her sisters to Florida, so it should come as little wonder that I did not overcome my own fear of flying until my forties, when the years I had left in which to live well were, I saw, like a lifelong Republican sees when she turns into a Democrat, fewer than those I had already lived. Alas, I am not returning with gifts.
MM

Sun., 12:57 p.m.
P—We're paused again, almost through this set of stanchions and belts, after which the Americans will X-ray our bags, shoes, etcetera again, before depositing us in the next set of stanchions and belts, and who knows how many after that. Of the teeming masses allowed to descend the stairs, we are at the epicenter, are in the slow hurricane's eye. Among us are the fashionistas and aspirational influencers, here to inspire. I have contributed to the group dynamics—to our mutant ensemble—primarily by showering and lightly scenting the dark zones. Although I underestimated its zeal, steeped in the winds of northwest Iowa and the protean theatrics of Minnesota, I have ample enough experience with layering to have prepared well for the weather we've faced. Seldom do I buy new clothes, but for this trip splurged, relatively speaking, on three types of merino wool for torso and feet, and lightweight, collapsible waterproof gear for the whole of me, from which I have been able to mix and match three regular ensembles that fit in my backpack, along with my toiletries, leaving room to spare, as if I had planned to bring back contraband. I felt horrible spending the money when I did, but now see the wisdom of investments that hurt in the present but set one up well for the future. Is it a fool who returns with room for the gifts he has not bought? Is it a student of Zen? I can color myself many new things.
MM

Sun., 1:01 p.m.
P—Bless he, she, or they to whom it occurred—a bit of molten common sense that bubbled up through the crust—that removing our shoes and belts for the second X-raying was, under the circumstances, no longer necessity. At the end of the X-ray line, along the back wall of the room, rows of people sit, and beyond

them further rows of people sit—those whom had been texting
their friends to inform us of what lay ahead, like captured scouts.
Adjacent to them are barley populated stanchions and belts. One of
the shepherds asked A. and I where we had been and were going. We
told her and were sent to the barely populated area, beckoning like a
private resort or villa we can't afford, past all of the sitters, for whom
we bottled the sudden rush of euphoria, a winning lottery ticket in
our hands. Before we could make it six feet toward the stanchions
in which we would be sole residents, kings and queens for the time
it took us to walk when we wanted to run, bridling and reining our
bodies with our minds and will, a second, darker shepherd engaged
the first, telling us to stop. Each was adamant, but the woman won,
which led to us being sent ahead though the Shangri-La queue.
The young girl A. had engaged earlier joined us, pretending to be
our child—a good, easy liar. I suspect she was coming from the
Schengens. Before we entered the saving queue, which we would
whoosh through like a water ride, we motioned to D. and L., just
exiting from a different X-ray line. We told them what the shepherd
had told us. Perhaps ten of us, A. and I at the front, made it to
the queue, accepting an undeserved victory, like a team that has
committed pass interference but sees no flag, before all such ushering
stopped, just as quickly as it had begun. I saw in my hyperbolic
mind's eye, which I was allowing free rein, helicopters leaving the
roof of the embassy in Saigon. If in one of those parlor games we play
I ever ask, *Why was I humming "White Christmas" during springtime in
the Dublin airport?*, you have the answer.
MM

Sun., 1:19 p.m.
P—I was in and out of the customs station in less than a minute,
subjected to only two questions of the name, rank, and number sort.
I did not even have to produce the CDC self-inventory papers we
had almost not got when we were initially directed to the wrong
queue at the start of our—six queue?—journey through Dublin
Airport, whereupon all in our party and a few strangers-cum-
comrades-in-arms in our vicinity found it good that I carry my
small pen, always ready for the world to show itself in a way I might
forget and be unable to share sans the act of converting it to words.
Our temperature was never taken. I did not see that anybody's
temperature was. We were, it seems, not the droids they were looking
for. In the long corridor past the customs stations that take one to the

gates and amenities are hand sanitizing stations about every twenty feet or so. Much as watching a joke played upon another that has recently been played on you, I watched traveler after traveler go up to the empty sanitizers, seeing how many they would try before giving up, going into a toilet, where the soap dispensers are full, keeping a straight face throughout, lest they knew it was a joke before we got to the best part of it.

MM

Sun., 1:43 p.m.

P—The current estimate from the attendants at our gate is that our departure will be delayed by only an hour or so. The mutual calmness with which the fluidity of our situation is both announced and accepted gives one the sense of being in a war film, although not at the front, but well behind the lines, waiting for a train to the next town. What we had heard in the last Irish line, which I had thought was official-speak, a bromide to tamp the itch, was, remarkably, true: the airlines are aware of the delays and are literally holding the doors until the last passengers make it through, not unlike the ending of *Casablanca*. It seems a handful slated for our flight are still in the queues, but how strange it is that the airlines know both whereabouts they are and whenabouts they'll arrive. It's rather straw on the camel's back of me to think of this as another nail in the debate on privacy, free will—all that we think makes us special—but there you are.

MM

Sun., 2:03 p.m.

P—I am going out as I came in, which is to say with a Carlsberg or two to thin the blood and provide that sense of lightness one from the plains gets at high altitude, when in the mountains. I have found a high stool in the seating area of the kind of airport food stand I would otherwise have passed by in favor of a more proper airport bar. My preset inclination to wander, to explore a bit, is unable to have its way versus what I can only call my generalized concern for safety and security, as if I am that liberal of legend who turns conservative with age. I am sharing the table with a retired couple—I'm the kid here—on their way back to California. A., D., and L., seated at the gate, have my pack. I feel like I have become the narrator of our set piece, at chapter's end, having to decide if the tale goes on or if ending on the power means I close things here. The worked-up boy with the Twins cap is back, whom I have not seen since the first

and second queues. His anxiety has become affability, now that he is at his gate—he is one of those the agents have been tracking to their seats on our flight. He is as good as home, it seems, to judge by his smile, by his host-of-the-soiree body language, as if past some denouement. I will not share with him that sensation of liberation until the jet has left the ground, when I imagine it will feel as though all day I have been running with ankle and arm weights that have suddenly been removed.
MM

Sun., 2:41 p.m.
P—A. came to gather me as they announced we'd be boarding very soon. I had forgot about the lax attitudes toward so many things that by all rights ought to be accompanied by such laxness, which is to say that folks are drinking beers and spirits at the gate. My thinking that I had to stay within the periphery of the stand in which my Carlsberg was purchased is yet another example of so much received puritanical thinking, an almost a priori cocoon I have been trying all my life to emerge wet-winged from. Being American in neither New Orleans nor Savannah has once again made me the fool.
MM

Sun., 2:45 p.m.
P—What a strange experience I am having, and how woefully unskilled I am trying to name it. I can't come up with anything other than "out-of-body," which gets at the heart of the thing as well as, oh, a squid can mow the lawn. I am me, to be sure—whatever I mean by that—but it's also quite suddenly apparent that I-as-me is, and has been, not just a self-contained thing clinging to a conception of free will, but is a kind of actor on stage or set, each setting and transition a scene in which my roll may be minor and may not come with any lines the audience hears. I am here/there, in the tapestry, an extra without whom would be a hole, necessary for one sense of things but not for another, and something the brain and eyes in their alchemy could trick us into believing is there when it's not. It is as if a door I didn't know was a door had not only appeared just now but had opened so wide that a second sun was flowing through it.
MM

Sun., 2:52 p.m.
P—I have, I think you know, in the face of the years of evidence that

make up my blip of a life, accepted that for things to truly change for the better—that for us to get out of the grip of corporations, their money, the power grabs of gerrymandering and vote/voter suppression, the stupid faith in free market capitalism and a framework of policy and law assumed to be benign but in actuality a framework making the rich richer as they siphon so much, and not just money, from the rest of us—as if we are their IV—requires some kind of revolution, that, Trump-fueled angst and anger aside, will not come from the ballot box. The very nature of a system itself which more and more instills a flawed but Constitutional minority rule by a minority that on one side is comprised by the aforementioned über rich and on the other side by evangelical—big E and small— acolytes who believe the earth is flat, that vaccines causes illness, to say nothing of their racism, their etcetera, is a system that must needs fall via revolution. And while it has been said by many smarter than I that no revolution is the same, I nonetheless prefer ours fall on the velvet end of the spectrum instead of the bloody one—though, given all the guns we've got, my thinking borders on the magical. I say all that as preface to telling you that we boarded the plane in a manner most unexpected. There were no divisions as to whom was first class, business class, or coach—no divisions as to who paid more for a ticket. We all just got on board, and I am for now, as I give optimism this moment, willing to allow myself to believe that perhaps this small egalitarian grace intimates better behaviors, large and small, individually and collectively, lay ahead. Perhaps this spreading virus is the velvet I seek.
MM

Sun., 3:00 p.m.
P—All are aboard, and the population is sparser than I have ever seen on a plane, as if we had been Black Mirrored to some utopia. So un-full is the plane that I am in my row and A. is in hers across from me. We could lift the armrests and take a not-undignified nap in a modified fetal position. Here, in the back of the plane, one not only commands the nation of one's own half row but has the buffer of empty rows between the occupied ones—the kind of border that will keep a peace. Have not heard from you since lunch at Portsmouth. These are seeming less like texts and more like letters. I have tried to keep them short, but there continue to be new things to be said. I am in airplane mode now, and you will likely get all of what I've thumbed out, all at once, when we land. It will be what nowadays

passes for a tome.
MM

Sun.
P—The Aer Lingus planes themselves are of the used-car set. There are visible signs everywhere of the wear and tear of time on a machine—loose things, torn things, no new-car smell. Among the many avenues it seems were available to one in the past but have been rendered obsolete, or certainly are on threatened or endangered species lists, is the one that makes of one a happy expat. Is there today a city equivalent to Paris of the 1920s? How did the Lost Generation make a go of it there? The very cities themselves have been co-opted by the haves more and more who keep taking from those of us left with less and less. Do not artists of different ilks congregate anymore? Is it the fault of education? Social media? All of the all of it? Perhaps the closest thing in our lifetimes, in our land, to the expats of 1920s Paris were those who moved to immerse themselves in the music scenes of Athens, Seattle, Austin, and, even for a time, our own Minneapolis. Or maybe it's the contemporaneous poets of Brooklyn. D. and L. have long been hoping to move overseas, their many travels less for sightseeing than to scout. But it seems that hidden between the lines of all the "life as a US expat" articles are foundations of considerable wealth. Is there today a Gertrude in Berlin? In Derry? I want to find her. I am a sad American whose education never forced me into anything but facility with our brand of English. Perhaps A. can transfer and I can teach that English in a place where experience in active-shooter lockdown drills isn't a plus. I would never force the cats to endure a flight in the cargo hold nor have them quarantined for a month. Perhaps my Gertrude is in a place where such is not a requirement. Perhaps we can get there via ship, C. and C. lounging in the cabin with us.
MM

Sun.
P—I had forgotten: that it will be light out all the way back home and then some—a kind of taste of the midnight sun. There are no doubt reasons having to do with wind speed, ocean currents, and the rotation of the earth, but each of the now three times I have flown from the US to Europe—after, as I said, a clear sense of limited mortality slew my fear of flying in a very deus ex machina way—we leave home at dusk, fly through the dark of a kind of night, and land at a real dawn

in the city of destination. Flying back it is as if all the lights in a room—those overhead and upright and on side tables, etcetera—have been turned on, and, if connected to dimmers, have been dialed to high. It is as if we are either preparing to search for the glint of a lost contact lens, or else are preparing to deep clean the whole of the room, or in the matter of travel via air, the whole of our lives.
MM

Sun.
P—I will have to reread *The Plague* ASAP and, in doing so, revisit myself in the form of old underlining and marginalia, a slow-motion, piecemeal version of what is claimed happens to one who drowns. I must, too, finally make the time to get to *Love in a Time of Cholera*, which I bought for A. too many years ago to admit, intending to get to it myself (like so many of the books on our shelves and shelves, which—don't hear me wrong—I am proud to be housed by, a cell of words in which I am like the prisoner free to leave who doesn't). I think I read somewhere, too, that Pamuk's next book, due out soon I hope, deals with either epidemic, pandemic, or plague. He has never not captured me to the full. How happy I am to not be among that increasing majority of Americans who boast like preening birds about not having read an entire book—to say nothing of their encounters with poetry—since their high school days. I have roughly as many books that I have gotten to as not on the shelves and shelves, a kind of happy nest that gives and gets. There are so many versions of me in the conversations I have had with these books, and so many inscriptions as to make good fodder for a scientifically reliable study on the handwriting of authors. To think of them all in a dumpster with the footstools, lamps, appliances, curios, and collections deemed not estate-salable is to think of a great unmarked grave of the unknown dead as coverup for an unspeakable horror.
MM

Sun.
P—A quirk of Aer Lingus is that we pay for drinks on overseas flights, something all other carriers I am aware of provide as a perk, the what-one-needs to get through it all supplied gratis. Math will have to be done before I would again book the cheaper Aer Lingus fare, to see whether Delta's, Virgin's, or some other carrier's higher rate does not end up being lower once the Bloody Marys are accounted for. Alas, I am over a barrel, joined by a strange memory

that has presented itself, almost like a tiny living room—a kind of
open-air snow globe minus the artificial snow—on the seat next to
me, and in that living space is the lot of us from grad school, seriously
discussing the ramifications of Tim O'Brien and his *The Things
They Carried*, his *Going After Cacciato*, his *If I Die in a Combat Zone,
Box Me Up and Ship Me Home* (which has a special affinity for me,
mentioning the names of the two towns I grew up in). As we saw it
then, with those serious and accepting looks on our faces, like dogs at
poker, we did not "have our war," and likely never would. Being past
draftable age, things would have to get bad for them to ever want us
to be the ones to take up arms and head to the front. Perhaps, tiny
living room from my Mankato days, our war has finally found us.
MM

Sun.
P—The murals of Belfast and Derry speak to the people in the way
that steeples are intended to lord over the devout. They are literally
a kind of watchtower populated by questions one must answer for
oneself. How do you remember what you shouldn't ever forget? How
do you keep in the minds of the young, when they are old enough
to world it on their own, who they are and where they come from?
Be they Protestant or Catholic in name, the real religion seems to
emanate from the murals. Dm. says that the ones in Belfast have
evolved, that there are fewer guns, fewer flowers indicating kills,
that they get repainted as the new détente becomes the norm, like
a slow-motion reformation of sorts. I do wonder what they would
think of ours, of the stars at First Ave, the Ravel score at Tenth
and Marquette, the giant faces of Dylan and Prince, which are
more for decor and homage than moral instruction. Though as for
Prince, he has been our calling card overseas, where very few know
of Minneapolis, so we must resort either to "It's close to Chicago"
or "It's where Prince is from." We entered a café in Paris once, on
that first trip after my mortality bested my apprehensions, if you'll
allow me to digress, when Prince was still alive, and his music was
playing loud, all of the staff singing along. His lyrics, as far as we
could surmise, were nearly the only English they knew. We ordered
primarily by pointing, and it took considerable time to get our waiter
to understand that we not saying we were Prince, which is absurd,
but merely from the same place as he. Much happy nodding and
smiling ensued. We have no Banksy sense to our murals. The non-
paean best of them are generalized or solidarity-focused, not unlike

our BLM and various All Are Welcome rainbow signs—even the Bernie and Say No to War with Iraq/Iran/Etcetera signs, and the few remaining Justice for Justines—that we stake in our lawns or tape up in windows facing a street. We have our wonderful young poets, many of whom are doing a Banksyish thing. Are they our murals? Our reminders? Their books steeples for our laps that remind us how fragile it all is as we transition from breakfast to the day? Perhaps. MM

Sun.
P—But for the cats and the necessity of showing up for work, I would have lobbied the group to have stayed in Derry, to ride things out there, dropping the traveler's cloak to try on that of sojourner, refugee, emigrant. But for the cats, the necessity of showing up for work . . . and the spending limits on our plastic. Decamping to Derry, of course, would require sacrificing the plants. I will not tell them what I almost did when I water them tonight. MM

Sun.
P—We have landed, and my phone is lighting up, all the messages hitherto in limbo released to the marriage of heaven, hell, and otherwise that is my phone. A. has been told to self-quarantine for fourteen days, and I assume my administrators will tell me as much. Classes are not resuming as scheduled, not for at least another week. Instead we are to meet virtually as a campus to plan the way ahead. Tomorrow is here. MM

Each epoch dreams the one to follow.

To dwell is to leave a trace.

I am not what I asked for.

— Jorie Graham

It is perfectly alright about the sweater. I don't expect you to be able to get it while you are quarantined, but will still be glad to have it if you can send it as soon as you are out of quarantine. It is rather cold ... but not cold enough to wear winter coat ... and my suit coat is a little too thin, so I figured out that a sweater would be the thing to have. Sometimes it is cold enough to wear a wrap while working, but of course it is out of question to work in a heavy winter coat. However, send it when you find it convenient to do so, and I will settle with you as promptly as possible.

— Lutiant Van Wert, during the Spanish flu, 1918

The joys of this world are joys still

Our mood-ringish faces
wonder-turn

 to death by fire
 arrived after its hero-journey

as the light of life, changing one kind of face
 into a different kind of face, unzipping
 coats we thought we needed,

 leaving them in balls, like
inexplicably abandoned homes.

A face
both holds a kite and is the wind.

 A face doing both, as faces do,
looks in at the shape

 beneath the covers
 flying its kites back and forth, dreaming

 of this if it sleeps on one side, of
 that if it sleeps on its back.

So. The sun is out.

 My face is an equation
 too big for the lesson board. My face

 needs a sheer
 mountainside, good carvers
 of stone,

fifty years of diligent work.

 The faces of geese teaching their young
 not to heed the die-cut, metal-dog

silhouettes intended to shoo them
 from the municipal soccer fields
 are very much like my own face was

before I walked out into the sun
I was o'er-swaddled thinking

 how important to teach the young.

I am reading the obituaries
as I used to read the box scores.

 The face I wear
 could easily be mistaken

as my response
to news that I lost an enormous bet,
 having gambled

 far too much.

 How to tell faces
 stupid in love

 from faces billboarded with the simple
joy of sun? It can make one feel

 sorry for the mosquitoes on the glass
 that won't survive the cold of night.

 But what to make of the hope
 that a warm spell gave to their hatching?

 Of the bats that will take

all the young and infirm come dusk? It is less easy

 to appreciate the smell of cut grass
through the nostrils of a primate

 once your primate face is melted, even

if you sort-of save it by putting the melt
into a mold. It is less easy to be

a lifeboat attached with quick-release
 rigging and clear pictorial instructions
 to the mother or father ship

than it is to be a lifeboat in use.

 What I think the tribe
 who refused to be photographed

 was trying to say: what miracle the suture beneath
the suture beneath the suture implied
 by the scar. As if there were a tent

 made of hospital sheets, nurses
rubbing on and in a body suit

 of salve: we are the thing at the center

of a shrine. The team of healing faces
 we can't picture all at once,

 those who came during visiting hours
 but were turned away—we

 remember how it felt

what was done with hands like hands and hands
like faces and hands like sun. We are

 surrogate pupa. They are our surrogate wings,
 too folded and creased and wet

 to fly, but not too any of that
 to try.

Naked truth

Life is not
like the president

we vote for
but the president

we get.

We were told
to cut the strings ourselves,

then life cut them for us.

We say many things and wait.

We are always courting espionage,
allowing lines of sight
like we do,

at our most empathetic

with our palms abloom
like perches,

as if we've nectar within,

are steeping not aging,
not even something

loinclothy for covering, just
flip-flops in case there are stones.

**Before the incineration part reminds us we don't know yet
where we want to be spread**

If I make a Japanese fan
 of the end of the day part

of today, detain the sky in lamb's
 wool and robin's egg, and

 one day you cool yourself
 with my record,

 then the motiony, cut-off-jeans-fringe
 effect at the edge of sight

that signals rain coming this way
 will continue to do its quenching work

long after it thinks it has died.

[Over the tiny rental I thought was a castle, like fairy dust to make it so]

 Are not we, too,
folded for another's use? Are not we all

 (sky included) as soon as we wake
extract diluted to juice?

*[Over the vats in the factory where they make the Bloody Mary mix,
in addition to things that those who are allergic must be warned of]*

One fan I made
was painted upon the readouts of lie-detector
 and EKG tests, and a doctor's note

 that said skip the juice, eat the fruit whole.
 I made it under the influence of luck. Headlights

 had helped me avoid a crash.

[Thimbles full on each of the names on my list of where to visit in Père Lachaise]

Chin-drip
 says I want to be chest-wet
so take off your shirt

 or hell leave it on
 and after we'll wash it quick.

[Hither and thither atop the lintels where nobody dusts]

Here's a fan I made of a summer night
 when the moon was like a flashlight

 held where I needed it to be held, like Athena
was on my side as I dug up the Tupperware

I'd Sharpie'd TREASURE CHEST on.

I blew the dust off of the lid.
I blew the dust off of the list

 I had made of people I never want to die,
 and added to it, inking in shrines of five-point stars

around my failures to wish hard enough.

*[In the fluid that makes the chemtrails, via which our lives are controlled
by forces of evil or good?]*

 It is a kind of portrait of hopefulness,
 the wet pitch that drops

from the urban planner's mouth
 in the urban planner's superpower dream.

[At the top of the Mississippi, sent to erode all the locks downstream]

 The old story:

I saw a country kid
and a town kid come at charity

 like it was carrion
 when one took the other's penny from the dish

by the till (it was my turn to take

 minutes as the acting secretary
 of that which used to be thriving).

*[In a cloud responsible for the late-season snow that nobody shovels,
waiting instead for it to melt]*

 The drool
 I've drooled out during sleep
 is a two-way mirror. Looking at me

 from the other side are the kids

who lived in what was called the Crippled Children's School

that the more Jesus-y than deacon-ish
men carried like frankincense and myrrh

 from car to pew and back

 so that the kids didn't commit the sin
 of missing out.

The two-way mirror, on this side,
 requires a refrain for allegiance,

 else it swears it will dry all up. It's

 why I'm singing, *Bop bop she-bop,*
 hey-ho.

[In the loam of the Côte des Blanc—eventually a thousand toasts]

I am going to cargo-hold
 the kids in my mouth, take them to the playground

 and faux scream and whee! They'll
spill into cracks, and I'll hands-to-temples think
 fertilize, and watch what rises, as if

 I am midwife.

[Like remnants of a light rain atop the trees that leak the sap that the industrious
among us boil into what becomes a slice of French toast's voila!]

Shining up and out
from behind the clouds: the end of the student's

 long day of frustrated trying again.

You have to be an expert to distinguish
 such student-shining from the shining of the teacher

who has failed at last to teach the thing.

[Just past the filters, by a friend I know works there, in the HVAC system at MOA]

 The thing is
 I am stuck because I signed a contract
 to mass-produce the best of the best

 is what the mass producers said
 ended up on the collector's plate.

I washed it by hand to give a half-life
 to the lamb's wool and robin's egg

 and denim fringe and wrecked blooms
 I thought I'd been the only one to see.

[In the bird seed they sell in bulk, a picture of a cardinal on the bag]

 It's not the dead returning
 from the dead, the feeling you're not

believing in. It's me painting you
 as I watch from the kitchen

 as you begin to make out
 the remains of the image on the plate beneath your macaroni

and sauce, and in the laboratory of your eye
rebuild it.

[Or surprise me]

The stocking cap I wear

 when I dig on chilly nights
 covers Athena's nipple. My head's
 the delivering breast.

[Perhaps on the pizza you eat while high]

 I'm giving you a once
in a lifetime chance for pebble-dropped-into-ness,

 for your lip and tongue work
 to radiate like all of Olympus

on volunteer-in-the-community day,
 the fan of now like an eyelash

 seen so close it looks like an X-ray
 of an X-ray of a wing, and you

are the eye looking out, letting
 in, weeping or fending off
 a foreign object, hard to tell

with all this ash and wind I

 can't distinguish what you're giving away
from what you're trying to hide.

Ultimately, god does not deserve to see

Beautiful woman without an arm, I looked
you in the eye. I kept my bag

> on the side I wanted to switch it
> away from, where it was digging in.

The mark has gone away.
The arm

> I wanted to lend out
> to make you whole

is my only beautiful part.

**Reluctant and irresponsible ode to the new lawbreakers
one acquiesces one would likely be were one still their age**

They are stepping right over
 where they know the trapdoor is.

Swirl cone, swirl coning,
 tornado, the suddenness,
 the urge.

 There was cool/warm.
 There was a slash

that mattered a lot.

 There was between.
 There was also

unbeknownst something
like needing

 to conquer
 as today there is

something like territory
re-flagged.

Now someone has glued a crowd
onto the scene.

 Someone
 has also glued onto the scene

a kind of animal belly

 we can cut off and cook
 in the sun and make

 a pleasurably edible thing.

Wanting to be plated with pretty
charcuterie and cheese

 is one of the reasons
 for public space.

 Like a revolutionary hero
 persuaded to govern

once the the revolution's complete,
and finding governing

 un-revolutionarily dull,
 I am going to

but am going to get in t-rouble for

 taking everyone's doll clothes off
and painting body parts
back on.

 Dangerous
 isn't as dangerous

 as it used to be

is what we who have survived
to now can say like it's advice, like if it feels

 as good as conceiving a baby,
 do it twice.

I am in the sun's display case, a kind of troubadour stage

My passage
to this small but important oasis

 was executed mainly
 with a sundial in my brain.

 How not to feel
 like the space between

 fence slats,
 like a reduction

in the field of vision? Oh how I miss
the precision work I could do

 had I not these hands
 fattened by kneading!

I am no longer unleavened, as if freed
from the ivory of a locket, now
with movable parts.

 I am like the heat lighting
 that wants you to believe

 its pantomime
 is the pantomime

 that carries messages
 during war.

All of the people
I thought were missing
 are in insect garb

 in the wild
 out in the open

saying, *Let's hog what we've got*
while we're here.

Handbooks reveal none of this,
not how unexpectedly

it can snow again,

 the flakes as large as birds,
 the birds

 that flock on bushes
 seeping into them,

as if through pores.
I am going to put on

 a jacket and cap and gloves
 and walk among,
 anon.

 I am secretly trying
to light a wick. It's like groping

 at echoes
 I want to be hardened

 enough to hold, believing
 that if we believe

whatever we believe hard enough,
we can glow.

 Imagine a mind of flame
 climbing paintings,

cabins, and trees,

 looking for home.

I invite you, Abu Sayeed, McDonald's worker in [expletive] Denmark, into my American dream

The McDonald's workers in Denmark get six weeks of paid vacation a year, life insurance, a year's paid maternity leave and a pension plan. And like all Danes, they enjoy universal medical insurance and paid sick leave . . . A Big Mac flipped by $22-an-hour workers isn't even that much more expensive than an American one . . . about 27 cents more on average in Denmark than in the United States. That 27 cents is the price of dignity.

— Nicholas Kristof, *The New York Times*, 8 May 2020

I will teach you how to put a glass
to a wall to hear

what doesn't want to be heard,
how to keep warm towels

that aren't towels really,
resurrectionishly

blowing on them
like a pitcher on a cold night

blows into clammy hands,
giving them to those

imperfect nudes

performing self-examinations
for outward signs of disease.

After making bread pudding
in prairie chicken suits,

we can dog sniff
out cancer

in time to save a life.
We can help the physicists

catch up
to our hollowness,

like spooky focals
that show what's missing

under bridges
and on sills

where spikes have been set
like a boulevard of trees.

We are all imperfect nudes,
Abu Sayeed, a vineyard

of potential things.
The nightmare

scenario is that we wake up
still dog sniffing

and all they say is
down boy, down.

I am a good
scrubber of things,

a responsible user
of cleaning agents

diluted
in that great diluter

water. I remember
the shit and sheets

and have checked the box

next to your name
without permission.

I paid the dream clerk
more than I needed to.

I have fallen asleep
in an awkward position

to open the portal,
adding blemish

to my nudity. There are

so many Americans,
Abu Sayeed,

dreaming a dream

that, like a well-needed rain
on the horizon,

is taking such a long time
to arrive. Such fronts

always contain
damaging winds.

Abu Sayeed, I am going
to be easy to find.

CODA
Minneapolis: The last week of May 2020

On Memorial Day, an officer from the Minneapolis Police Department put his knee on the neck of George Floyd for what was reported to be eight minutes and forty-six seconds (and was later revised by prosecuting attorneys to be seven minutes and forty-six seconds, then again after body-cam video was released to be about nine and a half minutes), killing him, for allegedly passing a counterfeit twenty-dollar bill. A teenage girl and other bystanders recorded and posted the killing. Weeks earlier, white males armed with loaded AR-15s protested business closures and other officially mandated responses to the COVID-19 pandemic outside the governor's residence. There was no police response.

An uprising followed the Floyd murder. Many protesters converged at the intersection of 38th Street and Chicago Avenue, many wearing masks, trying to social distance. The protests were met by militarized violence from the MPD—tear gas, pepper spray, flash-bangs, rubber bullets. The protests became riotous. Fires were started, businesses looted. Opportunists catalyzed the violence against the neighborhood and its establishments. In a widely circulated video, a white man dressed in black and carrying an umbrella and hammer smashes the windows of an AutoZone shop, one of if not the first buildings set on fire. The man flees as nonviolent protesters question him and his actions. Vehicles from out of state or with no plates are spotted in many neighborhoods. Homemade incendiary devices are found stashed in alleys and backyards, planted during the day for use at night.

Wed., 10:32 p.m., 27 MAY
MM—I'm home. It's a really long story and there are two sides to this. I don't condone the violence and the looting . . . and it's not my anger to judge. There were many present doing their best to stop the damage. I redirected two possible instances from Moon Palace and The Hook. I made it clear when I saw spray cans come out that these were local businesses with people that supported what we were doing. I believe my exact quote was, "Don't fuck it up." The liquor store was just ugly and inexcusable. I did not know about Target. Not everyone there was part of the violence. The police were doing their fair share of contributing (shooting people indiscriminately, pepper-spraying and tear gas whenever they felt like it). There was not one order given to disperse nor was there any effort being made to de-escalate the situation. None. Flash pods and gas were fired as they saw fit . . . no

reason and no plan. Marker rounds (I think they're called) were fired from the roof and people were hit who were doing nothing. I saw a young man get hit in the head with a flash pod. I helped carry a girl that had been shot in the head with a rubber bullet to a stranger's car to get her to the hospital. I went to help a Native Elder that had been sprayed directly in the face near the front line, and I was doused with pepper spray. I have now showered and rinsed and repeated several times. That shit is nasty. I was sprayed for helping a man that was down. I handed a rag (I had a bag full) to a kid and he was taking it from my hand and we were both hit with a rubber bullet in the hands. Again, I was helping. In my opinion, the cops were taking pride in their actions. I saw no effort to serve or protect anyone. We are in a really ugly place right now and my heart is broken.
P

On May 28, police abandoned the third precinct building in South Minneapolis, leaving it to be burned. The many who speculated that the MPD deliberately abandoned the neighborhood to let it burn found their speculation bolstered the following night when the police amassed to protect the fifth precinct building. A Minneapolis City Council member wrote to describe how the MPD systematically delays response to calls to blackmail the council into passing budget increases. The night is filled with sirens, choppers, bangs, booms. Curfews are announced. The burning and looting expands to St. Paul.

Fri., 12:30 p.m., 29 MAY
G—My city has been on fire for the past two nights, and a new mural is on the brick wall of Cup Foods, the store outside which George Floyd was murdered by the Minneapolis police. The mural features Floyd's face, his name, and the names of many other black men and women killed by police. We are still fighting for civil rights. Having Minneapolis on fire and the new mural on a street I drive down regularly has made even more poignant the history of Derry and Belfast and cements in my gut what a mural really can be and do.
MM

Fri., 1:44 p.m.
MM—I've been watching what's happening over there on television. Frightening times with the military-style police tactics that we've seen here for many years. Harrowing pictures of George Floyd and the treatment shown towards him. I would like to say unbelievable

but sadly it's not. I hope the mural can be the voice of the oppressed and downtrodden and the riots die down and voice of reason is heard. Sometimes when you haven't got a voice violence is the only option, but hopefully reason can win through. I heard Obama getting his message and hopefully he will be listened to. You need to get rid of your guy in charge, by the way. Nut job.
G

The residents of South Minneapolis felt abandoned. The neighborhoods organized, held mass meetings in public parks—Powderhorn Park, Martin Luther King Park, others—and developed plans for our self-defense. We packed evacuation bags, went on patrol, used social media and our smartphones to warn each other of suspicious vehicles, activity, people, packages, containers, etcetera. We watered our lawns down so that they would be harder to burn. We left our lights on and brought our trash receptacles up or in, or filled them with water, lest they be set aflame.

During the day and before curfew, couples and families walk their dogs. They are doing more than exercising themselves or their pets. They are our eyes and ears. Those with guns have them ready.

Provocateurs have targeted minority businesses. Firefighters were overwhelmed, the fires seeming to be systematically set far and wide to hamper a response. One Black-owned barbershop was set on fire in North Minneapolis. Many placed 911 calls to report the fire and were told they'd been put on a waiting list. Three hours later firefighters arrived and put out what flames remained, the barbershop a total loss. It is one example of many such responses, which later will spur rank-and-file firefighters to question the decisions of their leadership, criticizing them for not calling in assistance from neighboring towns.

The national guard, called in earlier in the week but not visible, along with the state patrol and state conservation officers, enforced the curfew and quelled the rioting on Saturday.

Reporters were arrested and shot with rubber bullets. Businesses further and further from the epicenter, already struggling from pandemic-related disruptions, boarded up and temporarily closed. People from the neighborhoods stood guard on rooftops, on

streets, inside businesses and other buildings, some armed with bats and guns, some unarmed, to stop opportunists from setting fires to beloved neighborhood establishments. Many community organizations and institutions cut ties with the MPD. The state filed civil rights charges against the MPD.

Many worry that the protests and the community self-defense meetings in the parks will spark a new wave of COVID spreading. For many, it was the first time they had congregated since stay-at-home orders had been issued.

The uprising spread across the country, across the world. Protesters filled the streets outside the White House. When some breached the gates, Trump and his family retreated to the White House bunker, and the White House went dark.

Sun., 31 May
The people of Derry honor George Floyd with a minute of silence at the "YOU ARE NOW ENTERING FREE DERRY" sign, maintained at what is known as the Free Derry Corner in the Bogside section of Derry, site of the 1972 Bloody Sunday massacre. The "YOU ARE NOW ENTERING FREE DERRY" sign was inspired by a "YOU ARE NOW ENTERING FREE BERKELEY" sign iconically associated with the 1960s US uprising in support of free speech, civil rights, women's rights, and against the Vietnam War, which overlapped and coincided with the start of the thirty-year-long civil rights uprising that was the Troubles.

A few days later
A mural is painted on Falls Road in Belfast depicting the MPD officer with his knee on George Floyd's neck in the street, next to the MPD cruiser. The three other MPD officers at the scene are depicted as the hear-no-evil, see-no-evil, speak-no-evil monkeys. Floyd's countenance hovers above them. Behind Floyd are the words BLACK LIVES MATTER.

A house in So. MPLS, early in the week
A dumpster is burning in the center of an intersection a block south of Lake Street, like it's a distributary channel, Lake Street being, reports indicate, the primary thoroughfare of flame. It's the kind of dumpster a landlord sets behind an apartment building to collect the

weekly trash for all the renters whose initials and last names fit in the small rectangles above the rows of mailboxes up front, mailbox setups that have always reminded me of mausoleums. I watch from a three-season porch with all the windows, double-hungs, open wide. On the various screens where I watch it—television, laptop, phone— the dumpster-fire scene looks like a party. There's a general sense of joy: dancing, hooting, hearty laughter now and again behind the reporters, sometimes making it hard to hear what they have to say, as if a fair number of really good jokes are reaching their punch lines. It is not unlike the sort of misbehavior and property damage that revelers would think long overdue on the streets here if the Vikings ever won a Super Bowl.

I feel like a media columnist doing what must be a media columnist's job, changing channels and refreshing, station to app to website, station to app to website. The four local television stations have, for the most part, ditched regular programming, sending whomever is available—a longtime sports reporter here, a weekend anchor there—into the field to maybe try their hand at what they thought they might be back in college, when 101-ish idealism held sway in the prefrontal cortex, years before that part of that brain would mature, when getting the job that best allows one to meet the demands of modern life would usurp control. Some of the reporters relish the action up close and others are more comfortable with a bird's-eye view, sorting into one camp or another as quickly as a body part indulges a reflex reaction. A lot of what's being covered is the same from station to station, app to website, only it's covered from different angles, like a setup at a sporting event. I'm looking for reporters venturing out. Having friends across the metro means Facebook provides me a pretty comprehensive map of where there's action, where's there's not. I am for the first time ever seeing utility in Twitter. I have discovered Unicorn Riot.

The revelers remain a block south of Lake and are thinking not *campfire* but *bonfire*, dragging into the intersection various smaller receptacles—those intended for recycling or compost, those that collect the refuse for single-family homes and duplexes, not the multifamily residentials. Though it is difficult to tell with their visages transformed by flame, what must be old household items left in the alleyways for solid-waste pickup are part of the fuel too. There seem to be actors and watchers, those setting fires, those who don't want to

miss it, FOMO types thinking, *This is history*. As the crowd grows on the various screens, a filling-in-the-blanks part of my mind is trying to see the people still inside the apartments, trying to see those in bedrooms? in basements? in the single-family houses and duplexes from which the receptacles have been repurposed? is it better to keep all the lights on or turn them off? is this like a tornado such that one is safest in the lowest interior room with thick walls and no windows? I imagine the children, the adults trying to calm them, the older children joining the effort, already changed. I think of the fear that perhaps only the refugees among us have antecedent for, the inheritors of transgenerational trauma trying to understand a vaguely tingling sense of déjà vu.

As I watch and try to listen, and cup my ear in case it helps—a primitive means of sussing *distance away from*—I think about how I first loved Minneapolis with the naiveté of a visitor, with no comprehensive grasp of it, one more among the carnival of silly humans falling in love at first sight with person, place, thing, idea. I have pondered for a long time now how to communicate something I only felt twice: the feeling of being so at home in a place that things one does not believe about past lives and destiny and the supernatural present themselves as the only plausible explanations, the feeling like a kind of disembodied hug in the clutch of which— the multiple armless arms—the words *anxiety* and *worry* are at least temporarily unintelligible. I believe deeply in the capability of words, revised over time, to capture that which seems in the present tense of a new or raw emotion uncapturable, and while capturing this feeling is something they have yet to do—these words and their souls that I see and hear as they reach out to me from the page every day—they tell me that there is still time. More than a decade passed between the moment I fell in love at first sight with Minneapolis and the day I moved an old carful of belongings to an apartment here. In the interlude, many, many visits solidified the sense that we could last.

My first time living in Minneapolis was in a one-bedroom basement apartment with a roommate. Each night, after my roommate went to bed in the bedroom, I constructed a sleeping pad comprised of a short piece of a sectional extended by a pile of extra couch cushions, so that my legs could stretch out and I didn't have to sleep in the fetal position. I worked a lot of temp gigs and found one I really liked at a hospital, where I was a courier for both documents (mostly X-rays)

and people, taking them from an orthopedic office on the eighth floor up and down the elevators to where they needed to go. They offered to hire me on with a raise, away from the temp agency— which they weren't supposed to be able to do so soon—for 30 hours a week. I felt like I'd gotten on the inside of something and had made the right connections, like the star of an Afterschool Special about a small-town kid who makes it. I'd worked a lot of jobs where I had to wear some kind of uniform, but scrubs somehow were different and made me feel like what I did mattered, like if I was buying a sack of tacos while wearing them I might get an extra one thrown in for free. The job would make my list of jobs I've loved and would do for my whole life if only they paid more, but even with the raise the offer wasn't enough to be able to make it without a second gig. I ended up taking a job that required a lot more manual labor but paid more per hour and had me working more hours per week, meaning I would only have to work the one job, not the one plus temp gigs as I could get them. My shift had me rising and arriving to punch in in the dark, and with it I was getting by, but not ahead, with little to no money to experience an array of the things that were part of all that I'd fallen in love at first sight with. Something had to change, so I moved not back home, but near there, in with relatives. I didn't know if I would ever live again in Minneapolis. I never thought I'd own a home. I certainly didn't think I would be in a position to call one of the streets of the town I'd fallen in love at first sight with mine.

What was a block south of Lake Street is moving further south. Obsessively switching and refreshing to follow the progress provides an optical illusion of three dimensions, though it's nothing on par with what you see in replays in high-profile NFL games, a wide receiver shown making a miraculous catch in what seems like a magical 360 degrees, as if captured by a drone camera that isn't there, a trick of the digital age. My illusion is analog. A handful of motorcycles are now at the head of the channel of flame, circling it, a halo of cc's. I have heard the motorcycles all night, on the move, east of me, west of me, south of me, north of me. I find the chorus of howling RPMs—the riders out-of-gear trying to out-rev one another—overly theatrical. I am a hypocrite. At the same time as I wry-smile at them rather than with them, I see the needle on a tachometer hard-bounce to the right and remember what it feels like to have my hand on a throttle, and wish I had a motorcycle still and the barely-populated, hot-summer-night streets of a town with

a single stoplight upon which to ride it. The time it takes for the revving to travel from the screens to my ears is less time than it takes for the sound of a bat striking a ball in an MLB stadium to travel from home plate to the outfield, upper-deck cheap seats. The street that the traveling bonfire—that seems less and less like a party—is coming down is mine.

On my front porch—following the movement of the burning and the motorcycles south via screen and ear—I have with me a memento of my small-town, Midwestern American upbringing: a 12-gauge pump shotgun, which was an upgrade from the single-shot 20-gauge that I'd learned to shoot and hunt with at the age of twelve. I had taken gun and hunter safety courses in two states (my family moved) and had patches on my sweatshirt and cards in my pocket certifying me ready and able. For more than two years, I researched and worked and saved, researched and worked and saved, and went with my dad after I turned sixteen to buy the 12-gauge—a Browning BPS—the only gun I've ever purchased, which I didn't even do, as my dad had to buy it for me, me not being legally old enough. I hunted ducks and pheasants and partridges as much as I could with it and for a season when I dropped out of college, and had to move home to work, got so good with the BPS that I would load it with only two shells—one in the chamber and one in the magazine. If I couldn't drop what I was shooting at in two shots, it wouldn't see my plate nor experience my many and varied attempts at making wild game more delicious than anything store-bought. The screens show that the fire party has progressed another block. I've traveled through the cross street a million times. I've taken the waterfowl plug out of the BPS. There are four shells in the magazine, none in chamber.

As with an involuntary reflex reaction, I automatically think out and think back and contextualize. I read a lot about this country, a lot about this world. I am intimate with historian Kathleen Belew's research, tracing the history and contemporary practices of militia and paramilitary movements in the US, beginning with dissatisfied Vietnam veterans who felt the US government figuratively and literally abandoned them, proceeding to the 1995 bombing of the Alfred P. Murrah Federal Building by Timothy McVeigh in Oklahoma City, to Dylann Roof murdering nine Black worshippers at a Bible study in Charleston, South Carolina, through the Trump presidency and Charlottesville and the attempted insurrection on January 6, 2021—

research she uses as evidence to support the understanding that the "lone wolf shooter/bomber/etcetera" is often not a lone wolf at all, but is an intentional bubbling up of a non-centralized guerrilla contingent in support of white supremacist ideology.

Tonight on the front porch, following the reporters as they name the cross streets and the fire line gets closer, will be only one unsettling night during this last week of May 2020. On another of the nights, five or six cars will drive down my street at intervals of perhaps ten seconds, perhaps twenty seconds, a kind of battle formation. The cars bear no license plates, are painted all black with the windows—save for the windshield—blacked out. Another night, the same number of blacked-out motorcycles will proceed in the same battle-ish formation, again at intervals of about ten or twenty seconds. The gossipy Nextdoor app will be used to identify and trace suspicious vehicles from neighborhood to neighborhood, a kind of citizen-brigade democratization of the surveillance state. Everything I have read from Belew regarding the desire of the white power movement to foment strife and eventually civil war, to come together when the time is right, feels like it is happening here, like Minneapolis has become a gathering place.

I have lived now in Minneapolis significantly longer than I have lived anywhere else in this world, and like any relationship that begins with love at first sight and is sustained to and through its silver anniversary, I see things more completely, see as much now that is hard to love as used to be easy to love. In the days to come, this street and many others in this neighborhood, in this city, will be populated with national guard troops, sore thumbs sticking out in our urban habitat with their desert-tan uniforms, their machine guns, patrolling in their desert-tan Humvees, a kind of negative-image of blaze-orange-clad hunters in the fall woods. In the days to come, I will hear or think I hear or dream I hear the hard-to-detect, night-flying special-ops choppers I see in based-upon-real-events films. I will sit on the front stoop, breaking curfew, watching military drones circle over my house, pausing directly above me, fearful of what they might be both able and willing to do. Eventually, on subsequent nights, I'll think then say *fuck it* and will wave at them when they pause overhead. I never get up the courage to flip them off.

My spirit is such that I would rather belong to the land than have the land belong to me. My spirit conflicts with my condition as homeowner, my condition as a person born in a time and place where what my spirit wants is not something it can't have. I have next to me (on the couch I will not sleep on until the sun starts to rise) my pump shotgun. I do not own a gun for self-defense. I own it because I once lived a different kind of life in a different kind of place than what I currently live here. I have the shotgun near me due to a condition that has been foisted upon me, upon my city. I do not yet know that when this week is over, when I stop not sleeping till the sun rises on the front porch, that I will go to unload the four shells from the magazine and will find that the gun is jammed. I have not used it since I went pheasant hunting in the mid-1990s. The inner workings have gummed up, such that it needs a deep, tear-it-down cleaning. What I do know is that the sound of a shell being loaded from the magazine to the chamber of a pump shotgun says *beware* when *beware* sounds more like *run, motherfucker, run*. What I do not know is that if I feel the need to make that sound—out of fear, out of a desire to protect my house, my wife, my cats with it—that I will be unable to, a dud.

I am hoping that the fire snake will stop growing south. It is, the reporters say, five blocks away. I go out to the sidewalk and look north. The blocks are long and the streets fairly flat in this part of town. I can see smoke against the black sky that on any other night I would think was emanating from a backyard fire ring—the kind of good time I'd like to join in on—and a red glow that I normally would attribute to lights on emergency vehicles. Some of the people who live on my block have already left town to be or feel safer elsewhere, and others will join them in the coming days. There are those on my block and the blocks further down doing what I am doing. Whether we are in our houses or not, whether we are afraid or asleep, whether we are owners or renters, whether we are acting, watching, comforting, or being comforted, we are neighbors experiencing something altogether new. We are Minneapolis. And we'll see what tomorrow brings—on our screens, our streets, our parks, in our alleys and yards. We'll text one another and will receive texts from friends and family in the suburbs, friends and family across the country, friends and family around the world. We'll have our coffees and eggs, our smoothies and toasted things, our teas, juices, cereals, our cold pizza slices, our pancakes, breads, fruits, pastries,

meats, cheeses, muffins, grains, noodles, greens, our fingers and thumbs intent, strangely savant translators pecking at the letters of the alphabet like birds.

Notes

The title of the following poem is excerpted from José Saramago's novel *Blindness*:

"Ultimately, god does not deserve to see"

Acknowledgements

Earlier versions of the following poems appeared in *The Banyan Review*:

"When we gather again, lap to lap to lap around a fire"

"As doubly good as the gift of socks from Mara Mori
is the acceptance of an offer to dance at highway speeds"

"Mobilizing"

The following poem was commended by Nick Laird in the 2021 Moth Poetry
Prize:

"I invite you, Abu Sayeed, McDonald's worker in [expletive] Denmark,
into my American dream"

PRELUDE 4 plus *CODA: Minneapolis: The last week of May 2020*, and an
excerpt from *THE ANNOUNCEMENT*, packaged and titled "The Ides of
March," was shortlisted for the 2021 Fish Publishing Short Memoir Prize.

This book was not the intent of the trip I took to the North of Ireland /
Northern Ireland in the spring of 2020. The intent of the trip was otherwise
and threefold: I wanted to do on-the- ground research for a study-abroad
course I was designing called Their Troubles, Our Troubles: Re-Seeing the US
Through the Lens of Northern Ireland; my wife wanted to visit her ancestral
homeland near Derry; our well-seasoned international-travel companions
wanted to visit one of the places they had not yet been to, to cross it off of their
list. When we left the states, people were getting sick here and there, but a
pandemic had not been declared. There were, in fact, far fewer known cases of
COVID-19 on the whole of the Irish isle than there were in Minneapolis/ St.
Paul and the suburbs that make up the Twin Cities metro area, let alone in the
rest of Minnesota. It seemed like we were going to a safer place where we were
less likely to catch it, that a sort of wisdom based on serendipity was saying *get
on the plane.*

Although books do not write themselves, many before me have claimed of
the process *of a book getting written* that they were less first cause, less creator,
more medium through which words from wherever-the-fuck are pressed into
the page. I add, with this book, to their clinical insanity my own claim not
of authorship but of service to something received. Whatever confluence of

things known and unknown that got these words on these pages, in your hands, I am but one of a responsible lot. Many thanks go to the fast friendships made with workers, fellow patrons, and others previously stranger at pubs, clubs, restaurants, markets, cafes, and shops, at sites of historical and cultural significance and of no significance at all, along streets, etcetera, in Belfast, Bushmills, and Derry—and at stops along the roads betwixt. Special thanks go to Gleann Doherty of Derry, to fellow travelers Dan Peters and Lori Morrow, to Patrick Werle.

The words on these pages are better by far for the editorial guidance of Tayve Neese and Hadley Hendrix. If there is anything approximating guardian angels in this world it is editors such as these. Thanks to the people of Minneapolis and the Twin Cities for staying here and working in as many ways as there are people doing so to make this a good/better place to live. I am old enough to know that, save for our own extinction, it is work that never ends. Thank you, Cleo and Charlie. The moniker "pet" does not do justice to the home you make of our house. Thank you, Angie—to the chapters we've yet to be written into and maybe write a bit ourselves.
MM

About the Author

Matt Mauch lives in Minneapolis, where he writes lyrical prose and poetry and, as a hobby, cooks. Mauch was born in a small Midwestern American town from which his parents moved two weeks before his first birthday and to which he has never returned. He was raised for a decade in a different small Midwestern American town in a new state, where he made friends and participated in social circles and felt like he belonged . . . until his parents moved to a smaller town that many would consider not a "town" but a "village," in a different state, far from urban areas, where to this day the Milky Way is every unclouded night's star of the show, unless the fireflies are out by the thousands or hundreds of thousands, hovering over fields of soybeans and corn, when the two compete for top billing. Trying to make friends as the new kid in middle school, Mauch never imagined he'd be teaching today in the amazing (his word for it) Associate of Fine Arts in Creative Writing program at Normandale Community College, in a first-tier suburb, a not-too-bad drive from his house in South Minneapolis. A second hobby when school is not in session is reading novels. Sometimes when he misses being able to see the Milky Way due to urban light pollution, he also thinks about his first jobs delivering a daily afternoon newspaper on a banana-seated bike, knocking on subscribers' doors to get their money, like a mafia lackey or collection agency, and on weekends cleaning the toilets at a gas station before people used gloves or cleaning agents that didn't cause cancer. Neither of these jobs has yet to make its way into his poems or lyrical prose, which has appeared in numerous journals, including *Conduit*, *The Journal*, *DIAGRAM*, *Willow Springs*, *The Los Angeles Review*, *Forklift, Ohio*, *Sonora Review*, *Water~Stone Review*, and on the *Poetry Daily* and *Verse Daily* websites. His work has been recognized with a grant from the Minnesota State Arts Board and as a finalist for the National Poetry Series and other national and international contests. Mauch founded the Great Twin Cities Poetry Read and the journal *Poetry City*, and has organized and hosted many other poetry readings and events. He is the author of five books, including *We're the Flownover. We Come From Flyoverland*, *Bird~Brain*, *If You're Lucky Is a Theory of Mine*, as well as the chapbook *The Brilliance of the Sparrow*. Long-inspired by William Blake's *The Marriage of Heaven and Hell*, this is Mauch's first work (unless you count the prose poems among his lineated poems not as poetry but prose) in that vein, known today as

a "hybrid" or "multi-genre" work, a popular but demeaning (again, his word for it) parsing of the whole.

About the Book

A Northern Spring was designed at Trio House Press through the collaboration of:

Tayve Neese and Hadley Hendrix, Editors
Joel W. Coggins, Cover Design
Hadley Hendrix, Interior Design

The text is set in Adobe Caslon Pro.

The publication of this book is made possible, whole or in part, by the generous support of the following individuals or agencies:

Anonymous

About the Press

Trio House Press is an independent literary press publishing three or more collections of poems annually. Our mission is to promote poetry as a literary art enhancing culture and the human experience. We offer two annual poetry awards: the Trio Award for First or Second Book for emerging poets and the Louise Bogan Award for Artistic Merit and Excellence for a book of poems contributing in an innovative and distinct way to poetry. We reserve the right to select other titles to publish from contest submissions.

Trio House Press adheres to and supports all ethical standards and guidelines outlined by the CLMP.

Trio House Press, Inc. is dedicated to the promotion of poetry as literary art, which enhances the human experience and its culture. We contribute in an innovative and distinct way to poetry by publishing emerging and established poets, providing educational materials, and fostering the artistic process of writing poetry. For further information, or to consider making a donation to Trio House Press, please visit us online at www.triohousepress.org.

Other Trio House Press books you might enjoy:

States of Arousal by Sunshine O'Donnell / 2022 Louise Bogan Award Winner, selected by Ed Bok Lee

The Fight by Jennifer Manthey / 2022 Trio Award Winner, selected by Aileen Cassinetto

Kaan and Her Sisters by Lena Khalaf Tuffaha / 2022

Live in Suspense by David Groff / 2022

The Fallow by Megan Neville / 2021 Trio Award Winner, selected by Steve Healey

Bloomer by Jessica Hincapie / 2021 Louise Bogan Award Winner selected by Lee Ann Roripaugh

Unceded Land by Issam Zineh / 2021

Sweet Beast by Gabriella R. Tallmadge / 2020 Louise Bogan Award Winner selected by Sandy Longhorn

The Traditional Feel of the Ballroom by Hannah Rebecca Gamble / 2020

Third Winter in Our Second Country by Andres Rojas / 2020

Songbox by Kirk Wilson / 2020 Trio Award Winner selected by Malena Mörling

YOU DO NOT HAVE TO BE GOOD by Madeleine Barnes / 2020

X-Rays and Other Landscapes by Kyle McCord / 2019

Threed, This Road Not Damascus by Tamara J. Madison / 2019

My Afmerica by Artress Bethany White / 2018 Trio Award Winner selected by Sun Yung Shin

Waiting for the Week to Burn by Michele Battiste / 2018 Louise Bogan Award Winner selected by Jeff Friedman

Cleave by Pamel Johnson Parker / 2018 Trio Award Winner selected by Jennifer Barber

Two Towns Over by Darren C. Demaree / 2018 Louise Bogan Award Winner selected by Campbell McGrath

Bird-Brain by Matt Mauch / 2017

Dark Tussock Moth by Mary Cisper / 2016 Trio Award Winner selected by Bhisham Bherwani

The Short Drive Home by Joe Osterhaus / 2016 Louise Bogan Award Winner selected by Chard DeNoird

Break the Habit by Tara Betts / 2016

Bone Music by Stephen Cramer / 2015 Louise Bogan Award Winner selected by Kimiko Hahn

Rigging a Chevy into a Time Machine and Other Ways to Escape a Plague by Carolyn Hembree / 2015 Trio Award Winner Selected by Neil Shepard

Magpies in the Valley of Oleanders by Kyle McCord / 2015

Your Immaculate Heart by Annmarie O'Connell / 2015

The Alchemy of My Mortal Form by Sandy Longhorn / 2014 Louise Bogan Award Winner selected by Peter Campion

What the Night Numbered by Bradford Tice / 2014 Trio Award Winner selected by Carol Frost

Flight of August by Lawrence Eby / 2013 Louise Bogan Award Winner selected by Joan Houlihan

The Consolations by John W. Evans / 2013 Trio Award Winner selected by Mihaela Moscaliuc

Fellow Odd Fellow by Stephen Riel / 2013

Clay by David Groff / 2012 Louise Bogan Award Winner selected by Michael Waters

Gold Passage by Iris Jamahl Dunkle / 2012 Trio Award Winner selected by Ross Gay

If You're Lucky Is a Theory of Mine by Matt Mauch / 2012

CPSIA information can be obtained
at www.ICGtesting.com
Printed in the USA
JSHW080728260223
38153JS00007B/9